APERTURE

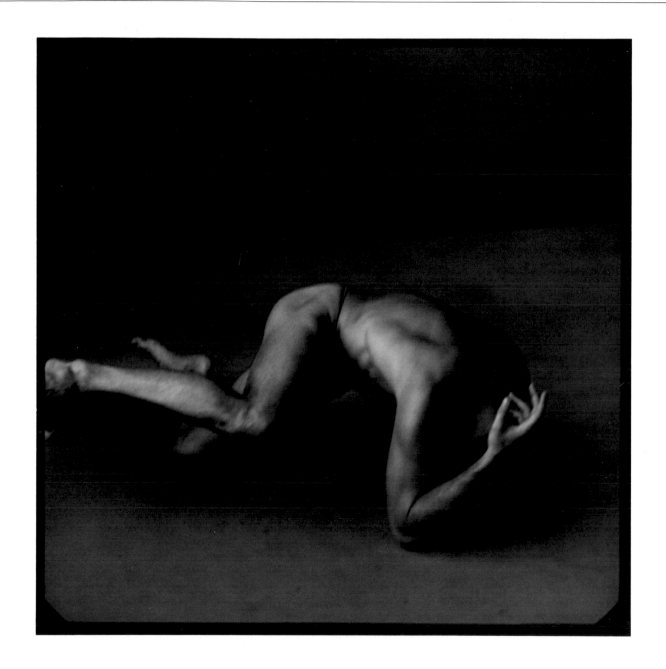

Adam Fuss, *Untitled*, from "Details of Love," 1992

ON LOCATION

What drives an artist to devote a lifetime to a particular medium, technique, subject, or investigation? What are the boundaries between an individual and his or her work? Where does the integrity—the "truth" in an artist's work—lie?

"On Location," the last issue of Aperture's fortieth-anniversary year, focuses on the working processes of seven well-established photographers whose remarkable images we have not previously published in depth. Through a series of lengthy studio visits and often soul-searching conversations, "On Location" explores the work and ideas of Adam Fuss, Jon Goodman, Annie Leibovitz, Susan Meiselas, Cindy Sherman, Lorna Simpson, and Joel-Peter Witkin—from the inside out.

Despite the widely varied nature of the work in this issue, a sort of subplot emerges—that of representation. Sherman invents a panoply of characters and roles. Witkin integrates myth, art history, and society's perceived outcasts in macabre theatrical tableaux. Leibovitz reveals personalities as they want to be revealed, while maintaining her own vision and integrity. Simpson critiques the treatment and stereotyping of African-American women through striking image/text artworks. Meiselas considers how to represent a culture that is not her own, a culture that, because of its chaotic history, may be virtually without a self-image. Fuss renders aspects of the organic world with cameraless photography. Goodman journeys into the past in his quest for more exacting interpretations of the present.

In venturing into these seven artists' working environments and presenting some of their most provocative images, "On Location" reveals the motives and idiosyncrasies that inform their extraordinary work. In the process, many of the issues surrounding representation—and its fundamental connection with all notions of image making—come into sharper focus.

THE EDITORS

ANNIE LEIBOVITZ

BY MELISSA HARRIS

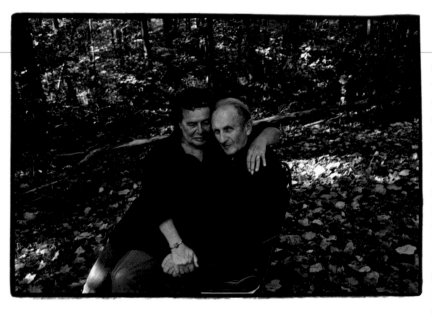

From interviews with Annie Leibovitz at her New York studio, March 31 and April 7, 1993.

There is some sort of crisis in my work, a shift in direction. Just a few years back I came to understand that the work couldn't always be about some assigned subject. It had to be about photography, and also about subjects that interested me. And this was a *big* thing. I knew it was going to be a huge commitment to try to change my work. It's hard to change, because no one really wants you to change; everyone wants bright colors, and they want people jumping up and down and smiling, laughing.

What is happening now is that I am finally doing pictures for myself. When I put together the "Performance Artists" series for *Vanity Fair*, I did it purely for myself; I was sure it was going to be put on the back burner and end up not being used. I was really surprised when Tina Brown said she wanted to run it right away. It was then that I realized that I am my own worst enemy. I'm the one, by doing what I think other people want from me, who has held myself back. I've been lucky with my work and I want to make the best use of this situation. I feel that I haven't let myself grow or listened enough to my own voice. It's so important to listen to your own voice. While I have done that, I've listened so much to everyone else as well. . . .

It's not as if anyone tells me how to go and take a picture, but I know what an editor needs, and I know what works. For example, a lot of my early work (not the *early* early work) was formed by photographing for *Rolling Stone*. The style—the overstrobed

style—came from working with them. It created *my* style: the two went hand in hand, the way I saw and what the magazine wanted. It would be wrong to say either that *Rolling Stone* made me or that I made *Rolling Stone*. But if you're together, you influence each other . . . you can't help but be influenced by the particular problems of a magazine. And although I can't really *change* a magazine's sensibility, I can add to it. I can say other things: I can show them that other things work, things that aren't necessarily part of the formula.

The mystery of the set-up picture is still important to me. I am

Above: Annie Leibovitz, *Marilyn and Sam Leibovitz, Silver Spring, Maryland*, 1992. These are my parents on their fiftieth wedding anniversary in their backyard, in Silver Spring, Maryland.

Opposite: Annie Leibovitz, *Diamanda Galás, New York City*, 1991.
This is the singer/performance artist Diamanda Galás. For one of her concerts, she performed a plague mass at the Cathedral of St. John the Divine for her brother, who died of AIDS. I wanted to shoot her there, but they wouldn't give us permission. At first I was just looking for some sort of equivalent of the church, but eventually the photograph turned out to be something much larger than Diamanda as the subject. It turned into something about women. Diamanda told me she didn't like this picture—she doesn't like her body, which I find hard to believe. And yet I don't. So many women have negative feelings about themselves.

I did this photograph for myself. I couldn't have used this in *Vanity Fair* because of the taboo against showing pubic hair. Really, nothing is simple when it comes to the question of nakedness. Every human body is different, and there are many ways of being naked and showing nakedness. Nakedness is just one way of being clothed.

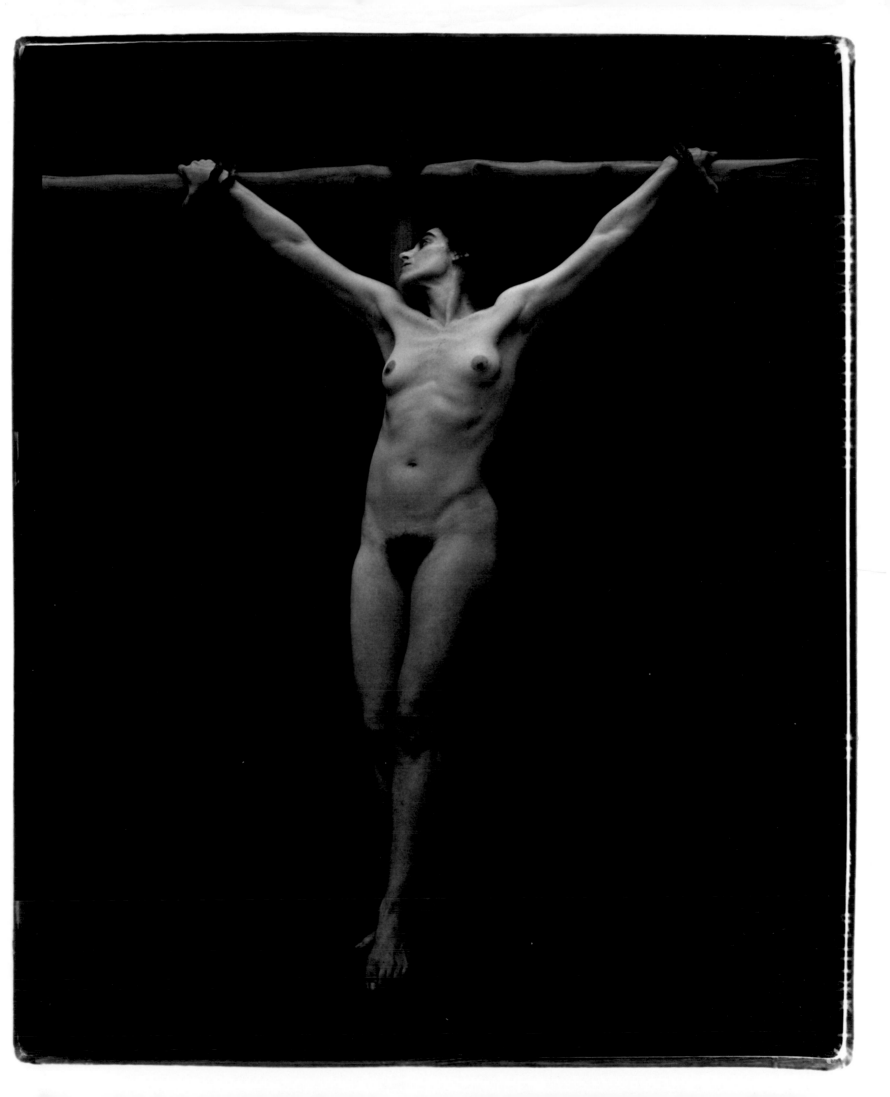

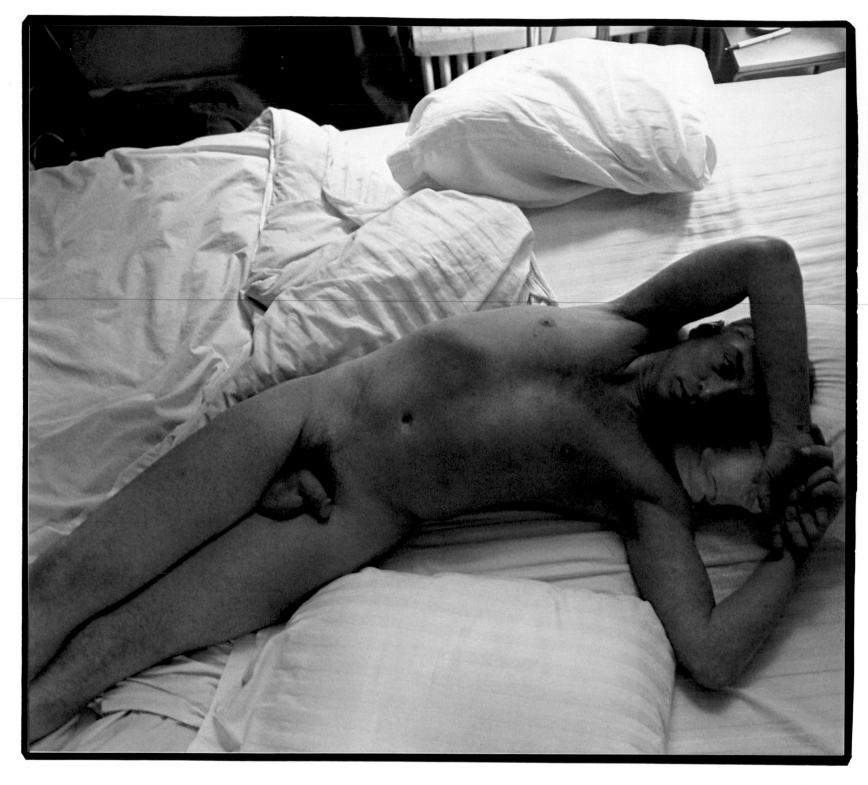

Above: Annie Leibovitz, *Ron Vawter, New York City*, 1993. When I was photographing Ron Vawter in his apartment, he said to me, "Do you want me to take my clothes off?" I was embarrassed, because I wouldn't have thought of asking him. And I was embarrassed because I didn't know if he thought that was what *I* wanted, and was just trying to be accommodating! But that wasn't what was happening. The photograph isn't about nakedness; it's about Ron's honesty, the honesty about who he is.

Opposite: Annie Leibovitz, *Evander Holyfield, New York City*, 1992. I decided to put him in the corner—it seemed appropriate for a boxer—and he did the rest. When he saw the picture, though, he felt that it made him look mean. He's not. He is not a Tyson. In this photograph, I was starting to mix strobe light with natural light.

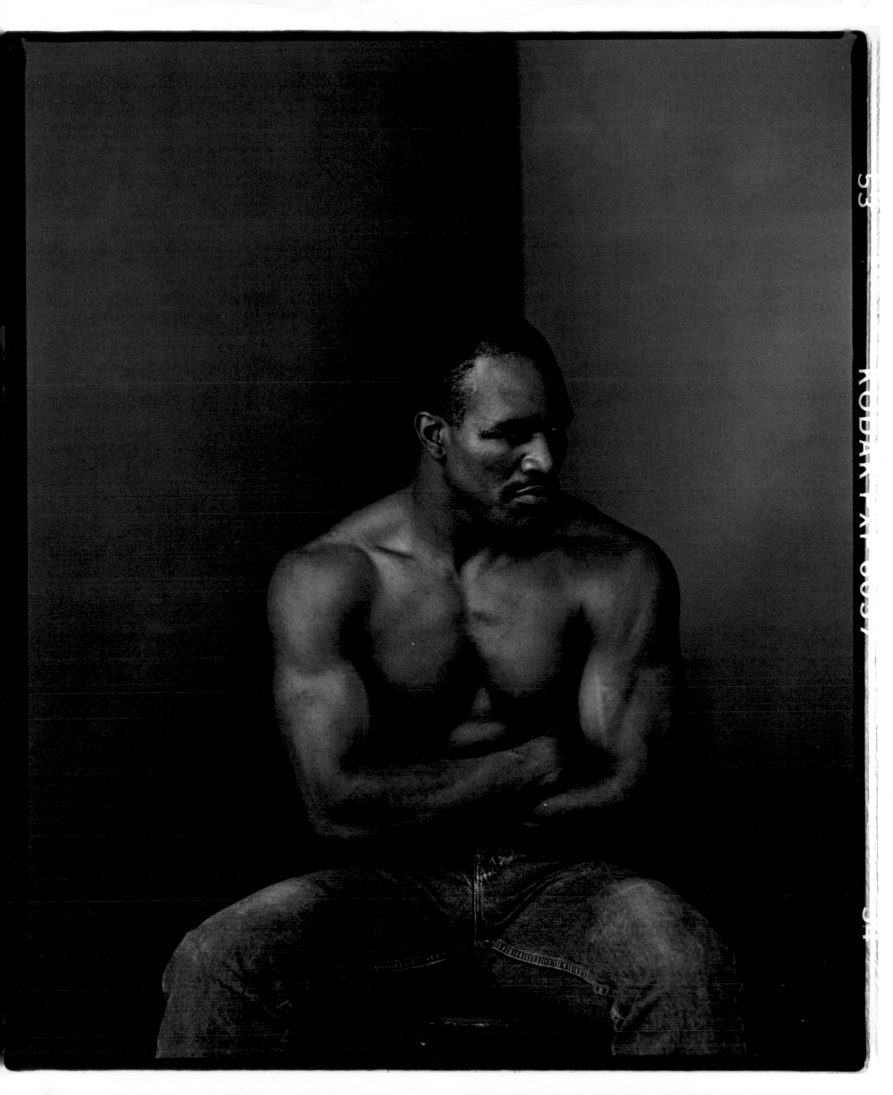

fascinated by the idea that the picture is set up and it is a session. At one time, I thought, "I wish my pictures could feel more spontaneous." I used to fight the studio, but now I am more and more attracted to the kind of beauty that can only be produced in the studio.

I'm surprised at how comfortable I am with things being formal, yet I will always wish things happened a little more . . . naturally. After you've learned to play with what you're looking at, it's really hard to stop doing that. You just want to make sure that if you're going to play with something, you're doing it for a good reason.

Now, it's so hard to say what work I do for myself and what I don't do for myself. I did the "Performance Artists" series for *Vanity Fair*, but I was doing it with a sensibility that was more personal, and as I said, I thought the pictures I was taking wouldn't be published. That was a great lesson. What made that series so compelling for me was, first of all, that I picked the subjects myself. Not that I haven't always loved doing the research on subjects that I'm assigned; that's the way that I claim them for myself. But it meant a lot to me to be able to pick the performance artists and to make the decision to select only women. I felt that the women had more to say than the men.

Right now, I'm working on a project on AIDS for *Vanity Fair*. It's

Annie Leibovitz, 1983. Photograph by Robert Mapplethorpe

been so moving to photograph people who are literally living with AIDS. They are still working and going about their lives, and they have all become even more extraordinary as people.

One of the subjects is the marvelous actor Ron Vawter. Ron operates on a whole other level. You end up going there with him, and you've got to stay close to the ceiling for a while! Then you leave him, and come back down. But you've been given a gift, because he's so generous with himself. He's really very special. While I was with him, he kept wanting me to see that he had AIDS, as if I had been walking right by it. He said, "You see my nails? Look at these bumps!" But all I could think was how beautiful he is.

After I left him, I thought maybe I wasn't addressing myself to the issue. Another subject was Tom Stoddard, the well-known lawyer and gay activist who teaches at New York University. Tom said he'd let me photograph him getting his chemotherapy. I wanted to show that this, too, is just a part of his life.

I also wanted the portfolio to include people living with AIDS who are not gay. And people who are not IV-drug users. I am try-

ing to present a more rounded picture. But I've found that it is hard to persuade people to be photographed regardless of who they are, whether they are successful or not. Many people don't want to be involved because they're afraid of losing their jobs, which means they would lose their health coverage.

I had better luck in San Francisco, where I've been doing a campaign for the San Francisco AIDS Foundation, photographing both HIV-positive people and people with AIDS. These subjects are a great cross-section of the city, and include a heterosexual couple. The man is a captain in the Air Force and he wore his uniform for the shoot.

Most of the people I photographed for the San Francisco AIDS Foundation want to look beautiful in the photographs. It's not hard to let them be beautiful, because they really are. I'm giving them what they want, and I enjoy doing that.

I like people to look good. I don't mean good as in glamorous. I was photographing my parents for their fiftieth wedding anniversary, and I thought, "Maybe I'm going to do an Avedon." I was thinking of the pictures he took of his father. Then I look at my parents and I *want* them to be beautiful. I mean, I want to love how they look.

My move from *Rolling Stone* to *Vanity Fair* was to try to discover and develop my own sense of what beauty is. But it goes beyond that; it's something I do naturally. I don't even know I'm doing it. People don't look like that; they aren't lit with a strobe. These days, I'm trying to get away from the "lit" look. I don't mind doing it on occasion, and there are times when it makes sense. But what I've been using lately is a combination of natural light with a strobe light only as a fill, or sometimes natural light alone.

Annie Leibovitz, *Rachel Rosenthal, Soggy Dry Lake, California,* 1991. With Rachel Rosenthal, I had two or three ideas. A lot of her performance work has to do with the earth and bones and being buried. When I first talked to her, I said, "I'd like to bury you." And she said, "Oh, that's my favorite idea! That's the one I want to do."

I found a dry lake bed near Los Angeles, but we learned at the last minute that at this particular lake bed we weren't allowed to dig any holes. So I arrived with my assistants at six o'clock in the morning, and we parked the cars in a circle like a wagon train and started digging. We put the dirt in plastic bags and hid the bags and then we put a tarp over the hole to hide it. Then Rachel came out, and we buried her.

I understood that the picture itself would be a performance: it should express her relation to the earth. She shaves her head, and that makes her head even stronger as an object. I became fascinated with her strong, bold head.

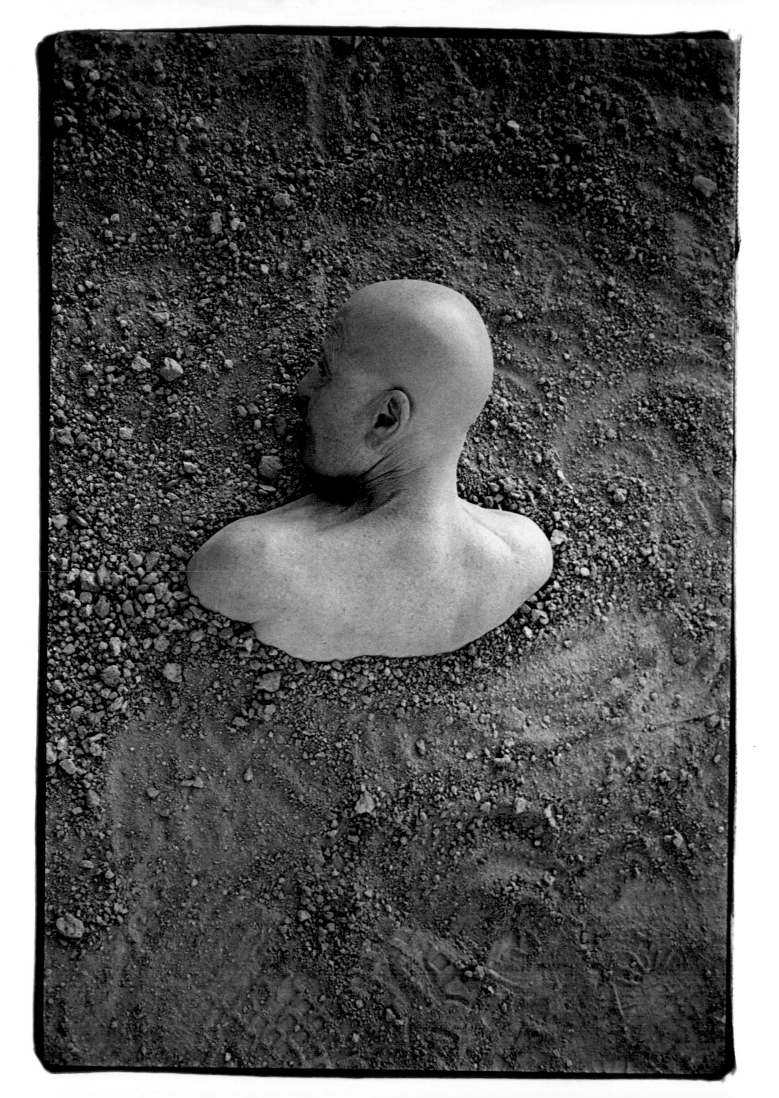

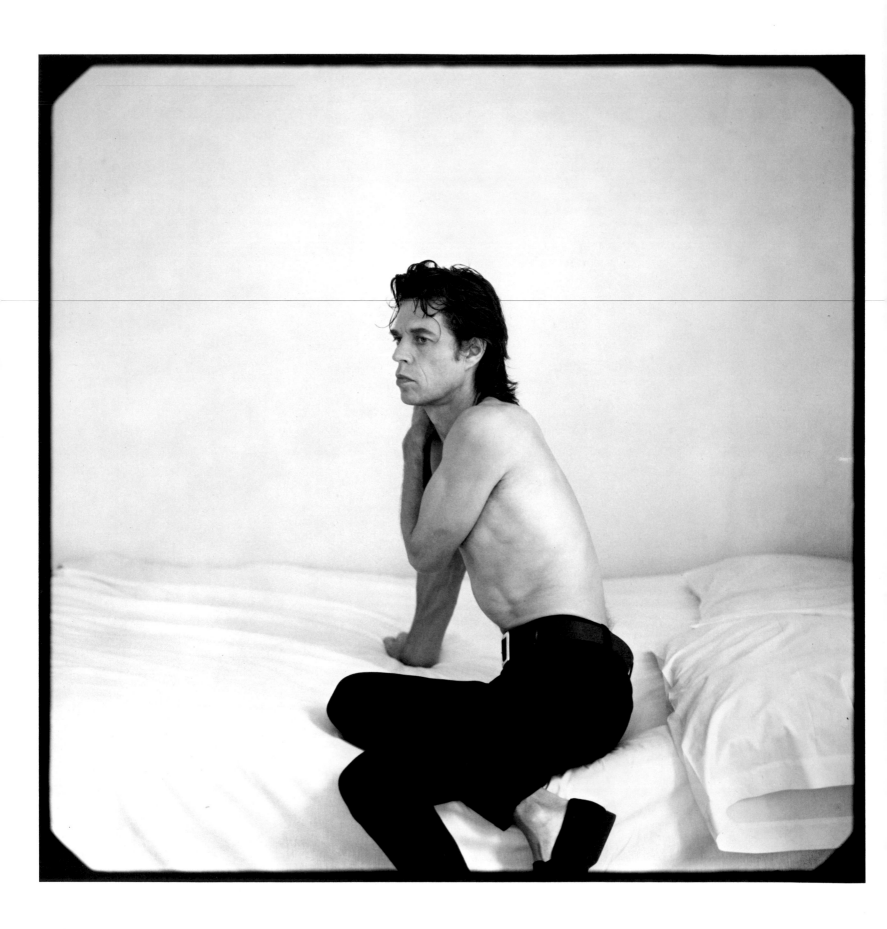

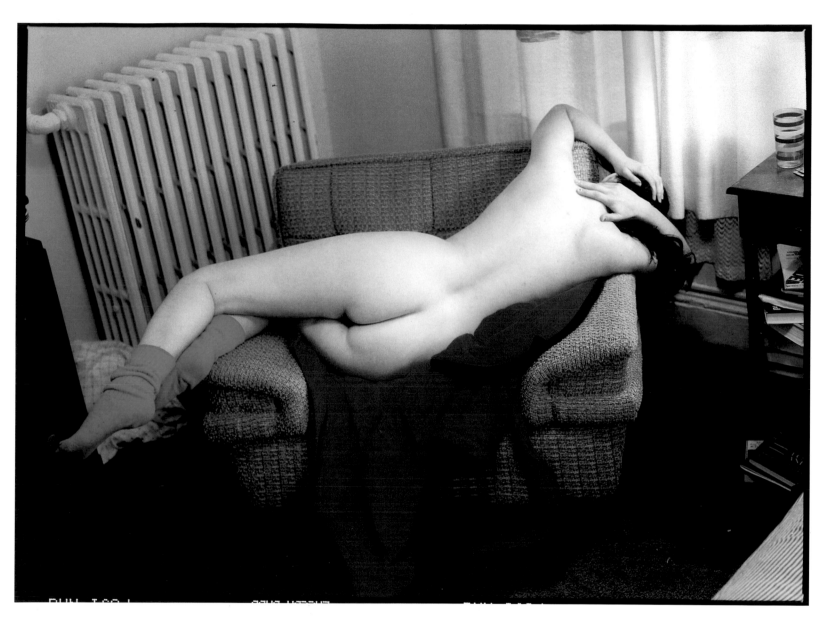

Above: Annie Leibovitz, *Karen Finley, Nyack, New York*, 1992. I went to Karen's home in Nyack, and she came to the door in a bathrobe and nightgown. She looked so beautiful in her nightgown, like a little girl—covered and uncovered—and I took a lot of photographs. As I was packing up and getting ready to leave, I asked her if I could photograph her nude—it somehow seemed so wrong not to. Her inclination was to refuse—she reserves her nudity for her performing—but she finally agreed. It was really interesting to watch her move around the chair. Some of her poses were provocative and sexual; others were about the body as something sculptural. But as soon as I saw this pose, I knew that it was what I wanted.

Opposite: Annie Leibovitz, *Mick Jagger, Los Angeles, California*, 1992. I let Mick Jagger become an object for me. He did that thing where he turns himself away a bit—a little hard to get. It was a very sexy shooting. It was only an hour or so, but he was *so* sexy, because he was doing exactly what he does to get what he wants.

11

In the advertising work I've done, again, no one has told me how to take the picture. I couldn't work any other way. Still, I don't want to underestimate how working for American Express or the Gap somehow does influence the picture—even though no one is telling me how to take it.

Sometimes my work for *Vanity Fair* can feel to me more like advertising than the advertising work does. The cover of the magazine is no longer, to me, a photograph. It's turned into a *cover*. It's one of the most frustrating things in the world for me when I go to shoot with very little time, and I end up spending the whole time shooting the *cover*, and never making a *photograph*. You know, there's a difference. The infamous Demi Moore cover is not a photograph to me. It has a kind of mental depth, but it doesn't have *photo* depth. It worked as a cover, though.

I started out as a photojournalist, and quickly became what people call a portrait photographer. Maybe portraits will always be what interest me most, but I've always wanted to take pictures without people in them. I've started doing assignments for Condé Nast's *Traveler* magazine. I went to Monument Valley for them. I loved doing portraits of rocks. It was an opportunity to concentrate just on light and form.

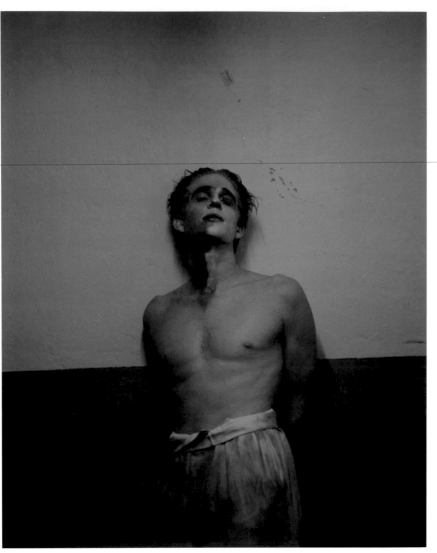

position of the photograph—because the camera sees so differently from the way the eye sees. And sometimes the real magic happens quite quickly, at the beginning, when you're taking the Polaroid. Afterwards you're sort of . . . repeating it. And it's not quite the same thing.

I'm still fascinated by the surprise of images—that images can be so powerful. And I want them to be powerful *before* they're laid down in the magazine spread. There are a lot of photographs that work well for magazines, but don't work outside of them. But real photographs have to have a life outside of the magazine; I mean, outside that very powerful form of presentation a magazine provides. Each image has to stand on its own. But being shown in a magazine, like *Aperture*, or in the sequence of a book, like the recent big book of my work from the last twenty years, or on the walls of a museum or a gallery—these are also powerful forms of presentation. It's always interesting to me when the single photograph is put together with other photographs. That's when I see best what I'm doing. I realize how much I'm simplifying everything, to get at some essence of a person or an idea, and trying to say more with less.

When I take portraits of people, I can usually get them to relax—although I don't try to make them relax. In fact, I'm as interested in someone being uncomfortable as I am in their being comfortable. There is a myth that the portrait photographer is supposed to make the subject relax, and that's the real person. But I'm interested in *whatever* is going on. And I'm not that comfortable myself!

I use the Polaroid a great deal with the portraits. I really rely on it as I shoot. And the very first Polaroid image is often the one I end up redoing on film. I feel safe with the Polaroid, because it's not the real picture. I think what I'm doing is exploring the com-

Above: Annie Leibovitz, *Matthew Modine, New York City*, 1992. Matthew Modine paints, and he wanted to paint himself. I was reluctant to let him do it, because I have a reputation for painting people, or putting them in the mud. I said, "People are going to think that *I* painted you." But he really wanted to do it, and gave himself a dark side as well as a light side.

Opposite: Annie Leibovitz, *Demi Moore, Los Angeles, California*, 1992. I needed six days of shooting to get the second Demi Moore cover, which was an exercise in artificiality. At the end of the shoot, I just let her be herself and do whatever she wanted to do. She stood by the TV set. The news was on, and then an electric chair appeared on the screen. I thought, "This looks staged, but it's real."

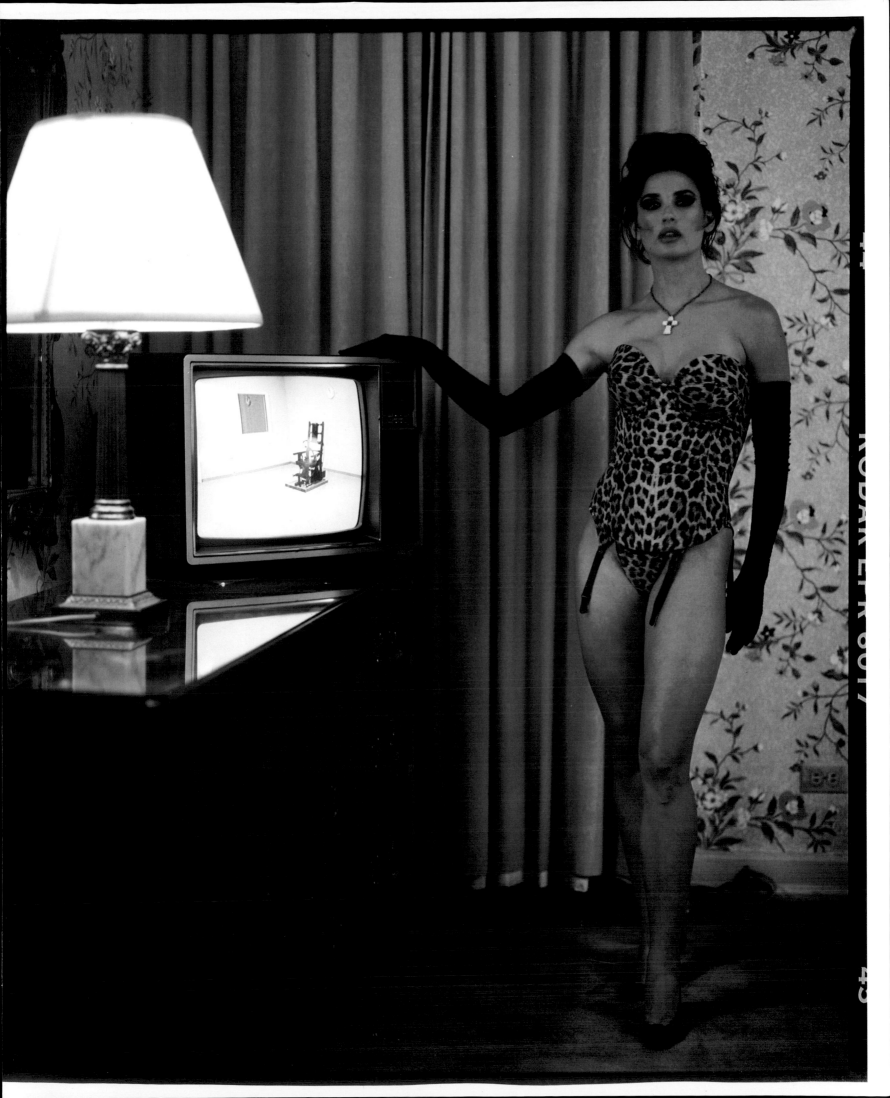

LORNA SIMPSON

BY ANDREW WILKES

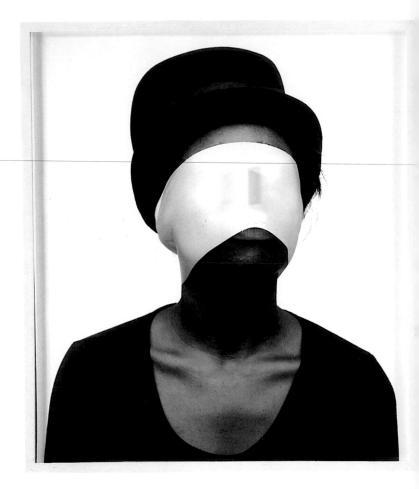

Lorna Simpson's photographs are documents of and testimonials to real-life situations, told through the use of symbolic figures and allegorical situations in order to create a narrative. Simpson demands active participation from her audience, offering hints of meaning without telling us what to think. Her work is rooted in her experience as a woman and an African-American. Complex issues of gender and race are conveyed through the use of disjointed texts combined with visual imagery, often resulting in troubling impressions.

Last spring, Aperture arranged with the Polaroid Corporation for Simpson to work in their 20-by-24 Studio in New York City, which houses one of only five 20-by-24-inch Polaroid cameras in the world. The camera is five feet tall, weighs 235 pounds, and, for ease of movement, is mounted on wheels. With a full-size Fresnel viewing screen and lenses that range from 135mm to 600mm, the camera has an actual image area that measures 20 by 24 inches, the final print measuring 22 by 30 inches. It uses Polacolor ER, a fine-grain, glossy, color film, and produces a contact photograph in seventy seconds. The camera was developed originally as a tool for medical research and for making replications of artworks; it was not until 1978 that Polaroid donated it to their artists program.

With her grant from Polaroid, Simpson created a one-of-a-kind, twenty-five-panel installation, entitled *Twenty-five Candles*. In her current body of work, Simpson is exploring themes of death and absence, using candles to represent the passing of time; the large prints and the instant results are very useful in creating her conceptual installations.

Simpson began to question the objectivity of documentary photography early on. By the end of her undergraduate training at the School of Visual Arts in New York City in the early eighties, she felt the genre was too limited and potentially exploitative.

She left New York and went on to graduate school at the University of California at San Diego, where she soon began to combine the visual aspect of her work with narrative. "I had always written stories and taken photographs," she explains, "but I had kept the two very separate. This was a merging of two activities, a time for reexamining the viewer's relationship to photographic imagery."

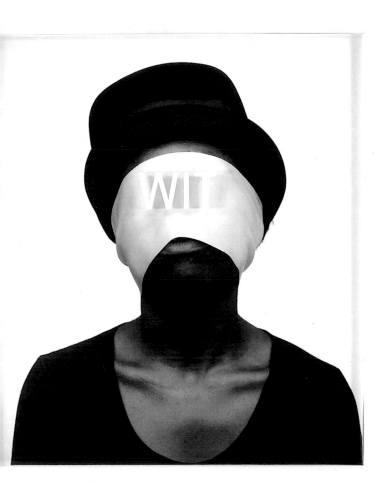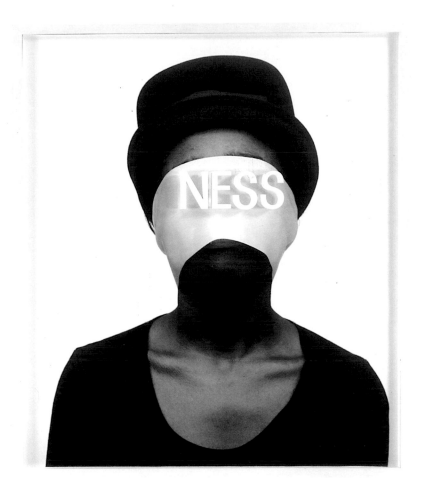

Lorna Simpson, *Sounds Like*, 1988

Nineteen seventy-nine was a turning point for Simpson's work. She was invited to participate in an exhibition, and wanted to convey a theme that was not possible in a straightforward documentary style. She created an assemblage photograph showing a dress with inspection tags placed all over it, but the tags told a story about the life of the dress's owner. By manipulating materials, she managed both to recount a chronicle and to comment upon the narrative.

The images follow the words in a Simpson piece—and the text is worked over, often right up to the very last minute, when the work has already been hung. The imagery, however—perhaps due to purely pragmatic considerations of printing and format—must be decided upon and fixed at an earlier stage. "If I'm lucky, the words come first," she says. "When my pieces are successful, the words are far more difficult to come up with than the images."

Simpson cites numerous African-American literary influences: James Baldwin, Ntozake Shange, Alice Walker, and Zora Neale Hurston—writers who have made new use of language in order to

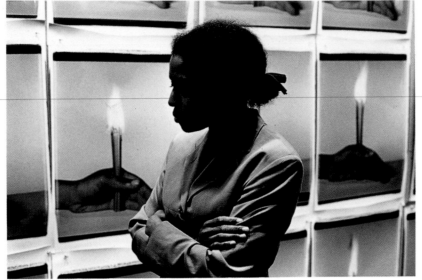

Lorna Simpson at the Polaroid 20-by-24 New York Studio, 1993

describe the black experience. This reassessment and reapplication of language is evinced in Simpson's texts, which often recharge a single word or a series of words by deploying it in new and provocative ways. Simpson maintains that her work is influenced principally by her own life—much of her work is autobiographical, yet it often addresses experiences relevant to black women collectively.

Proofreading, 1989, depicts a woman's face four times, covered with plaques bearing the letters *M-I*, *X-Y*, *R-U*, *B-Z* (a phonetic rendering of "Am I sexy, are you busy?"). This is an unequivocating critique of a situation black women face constantly: being addressed and seen as sexual objects to be appraised and seduced. Another work from that year, *Three Seated Figures*, shows the same woman seated in slightly varying, rather uneasy poses, with text panels to the side of and above the images that read: "Her story," "Prints," "Signs of Entry," "Marks," and "each time they looked for proof." Here, Simpson provides enough information for us to deduce that this narrative deals with rape and with the skepticism of the media and public officials toward a woman—especially an African-American woman—and her story. These two works were among the first in which Simpson employed repetition as a way to expand a single figure—herself—into a collective persona.

Simpson has also used the free-standing folding screen as a poignant method of presentation for her work. In *Screen 1*, 1986, three panels depict a seated black woman with a toy boat on her lap. On the front the text reads: "Marie said she was from Montreal although"; and on the back: "she was from Haiti." "The installation plays on the concept of screens and the 'screening' of identity," she notes. The panels not only confront the spectator with reference to the "hidden" self, they also hide viewers from one another.

Around 1990 Simpson began to incorporate images of hair and symbolic objects into her work. Since that time, coiled and braided hair, African masks, shoes (often used as gender-specific stand-ins for people), and shoe boxes have served as props in her work. In 1991 She began putting together images of hair with images of African masks. But instead of presenting masks from the front, Simpson orients the audience to the *back* of the mask, putting the viewer into the position of the wearer, disrupting and challenging easily adopted cultural perspectives.

Recently Simpson has moved away from working with the full figure to close in on different parts of the body, such as hands or lips. "I focus on details, either of the body, or of objects that represent gender, sexuality, and other themes." She purposely disrupts the viewer's vantage point, using serial images and turned-away figures—not allowing enough information for the viewer to classify the subjects. The body itself becomes a barrier, and the viewer, unable to be a voyeur, must turn from the images of bodies to the text, which does provide some disclosure. In Simpson's photolinen *Stack of Diaries*, the text describes one person's inability to continue writing in a diary and another taking it over. With this work, she has carefully created an ambiguity as to the genders involved—is this a relationship between a man and a woman, or two men, or two women? Here, Simpson plays deftly with gender themes: "It's about relationships between people, individuals who have been abandoned." If a diary represents a means by which to record things that happen to you, Simpson takes the concept a step further by creating a narrative charged with issues of control: Who is keeping the record? Who is controlling what? And who is controlling whom?

Two Bodies of Water, 1993, consists of two 30-by-40-inch black-and-white photographs—one upside down, one right-side up. The text reads: "Record time for holding breath, record time

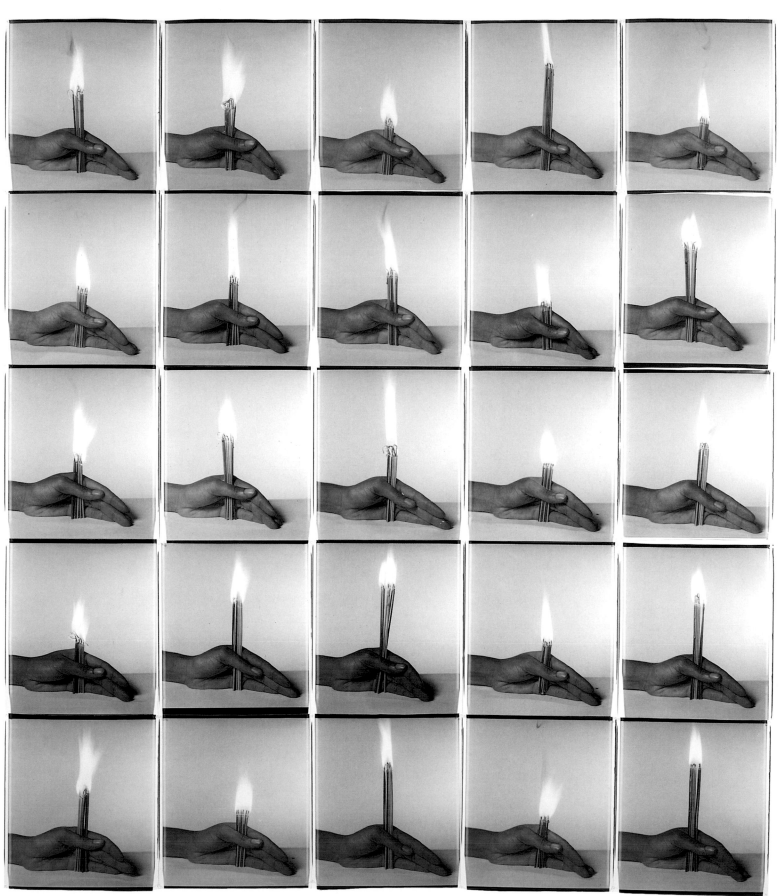

Lorna Simpson, *Twenty-five Candles*, 1993

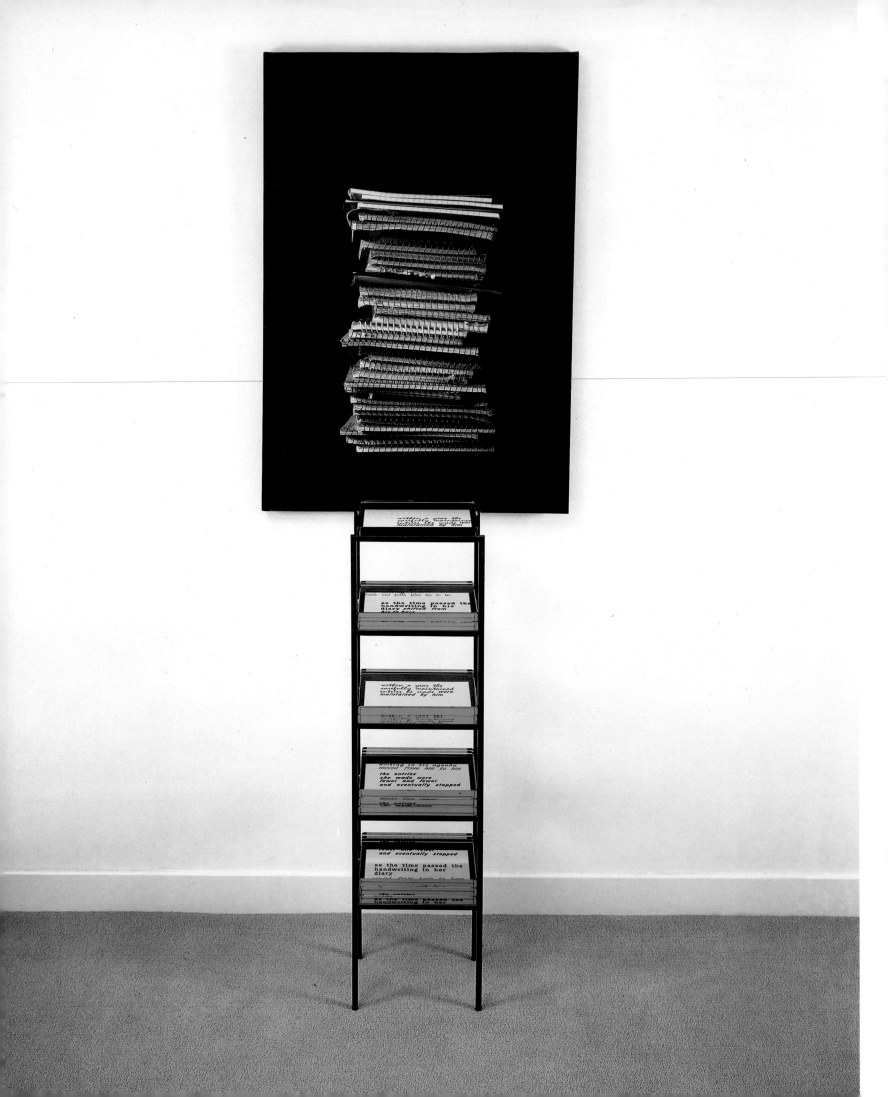

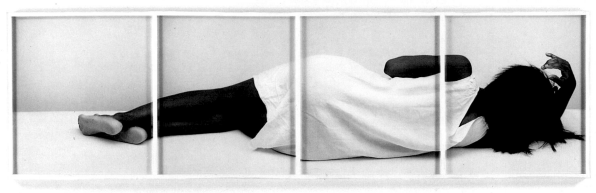

Left: Lorna Simpson, *Stack of Diaries*, 1993 *Above*: Lorna Simpson, *You're Fine*, 1988 *Below*: Lorna Simpson, *Five Candles*, 1993

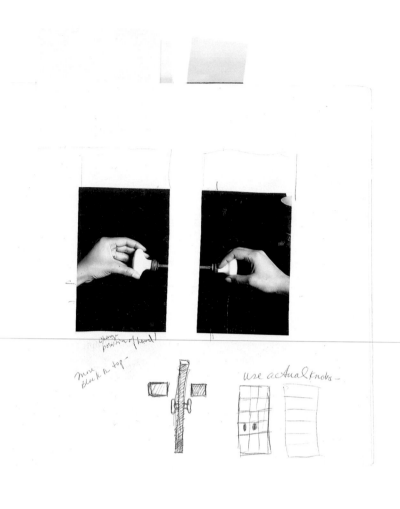

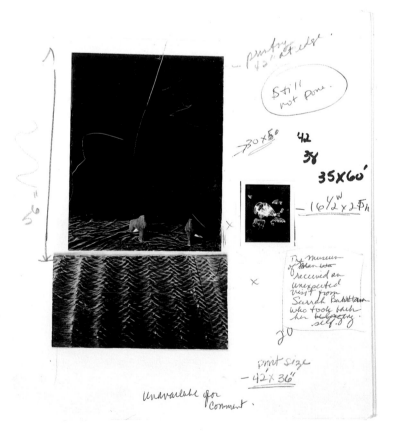

for treading water." Here, Simpson puts a spin on clichés about "keeping one's head above water." As she puts it: "It's about trying to maintain yourself, and keeping buoyant, and not being overwhelmed." Another recent work, *Upside Down/ Right Side Up*, consists of two prints of life-size empty shoes; again, one is rightside up, and the other is upside down. "In Western art the representation of a figure upside down is death. So this is about absence of someone missing—that double absence of death." Simpson thus symbolically conveys feelings of absence and of loss; the lack of text in the work itself (almost unprecedented for the artist) testifies to her shift in this direction. Simpson further examined these themes in a recent untitled installation of five sequential photolinens, showing a hand holding candles that are burning downward. Below the photolinens, the artist incorporated photo-engraved sheets of glass on which a pair of shoes is depicted. The shoes are printed with progressive lightness, so that over the five pieces of glass they eventually disappear. The work touches on the idea of ephemerality, both temporal (the candles as symbols of time passing) and existential.

Unavailable for Comment, 1993, deals with the narrative of Saartje Benjamin, "the Hottentot Venus." Also known as Sarah Bartman, Benjamin was a South African woman who was brought to France in 1810 and put on display as a spectacle in Europe. Upon her death, French scientists dissected her genitals, which remain preserved in a jar in the permanent collection of Paris's Musee de l'Homme. Simpson's photograph shows a body of water and a pair of shoes standing on wrinkled velvet with a broken jar. The text, in French, reads: "Today Sarah Bartman visited the museum, this was unexpected, she disrupted the daily life of the museum." Simpson comments: "In the work I did before this, whatever discourse it had about race was more about identity—construction of identity—but is identity the race?" This piece, she feels, deals with identity. The jar is broken: the atrocity of the displayed genitals has been in some measure vindicated.

Simpson's work is not a portrayal of victimization or a direct expression of empathy; rather, it delves into the dynamics and power of experience itself. Her subjects are survival and survivors. The language and the makeup of Simpson's pieces serve to disrupt us, to jar us from our habitual mode of coming to terms with the photographic image. Simpson realizes it is unlikely that people will grasp the full meaning of her assemblage photography right away. She says, "The only thing I can hope the viewer will get from the work is something about the structure of the work. It would be asking too much, I think, for them to get my exact intention. But if—through the construct and use of language, the way things are juxtaposed—there is some sort of disruption of the way you would normally go about reaching photographic images…if that is happening, that's fine."

Top left: Lorna Simpson, sketch for a work in progress, 1993
Bottom left: Lorna Simpson, sketch for *Unavailable for Comment*, 1993

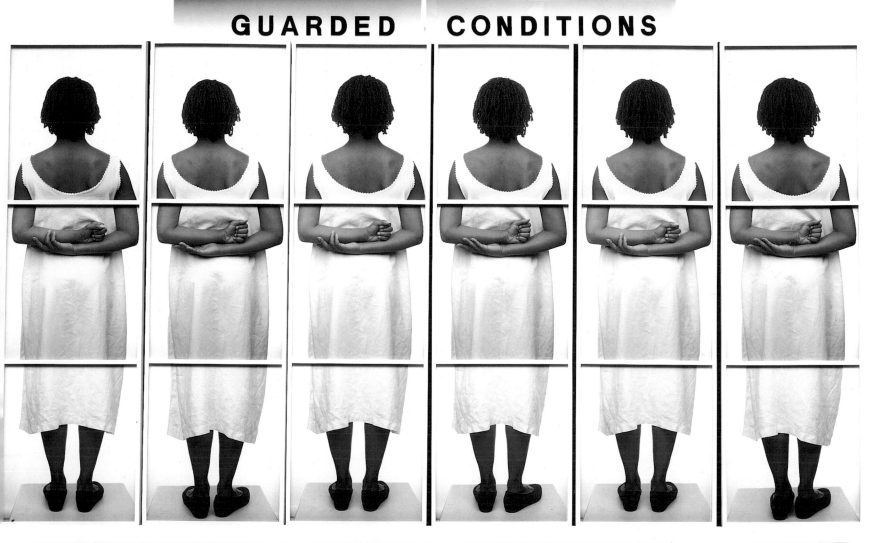

Lorna Simpson, *Guarded Conditions*, 1989

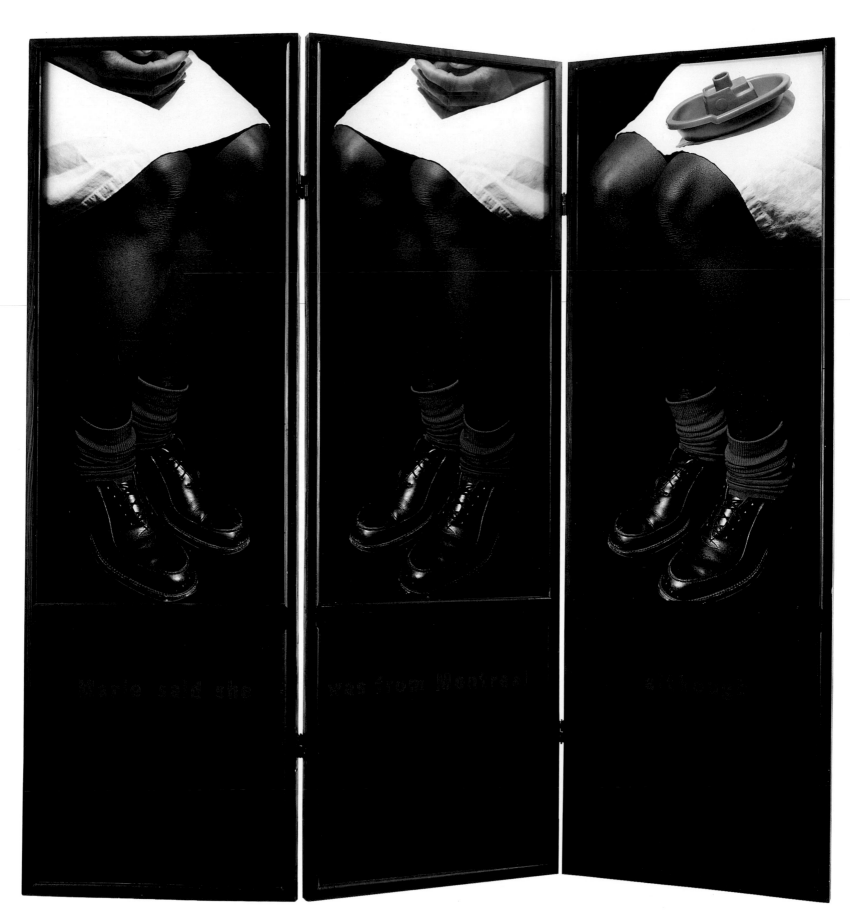

Lorna Simpson, *Screen 1* (front), 1986

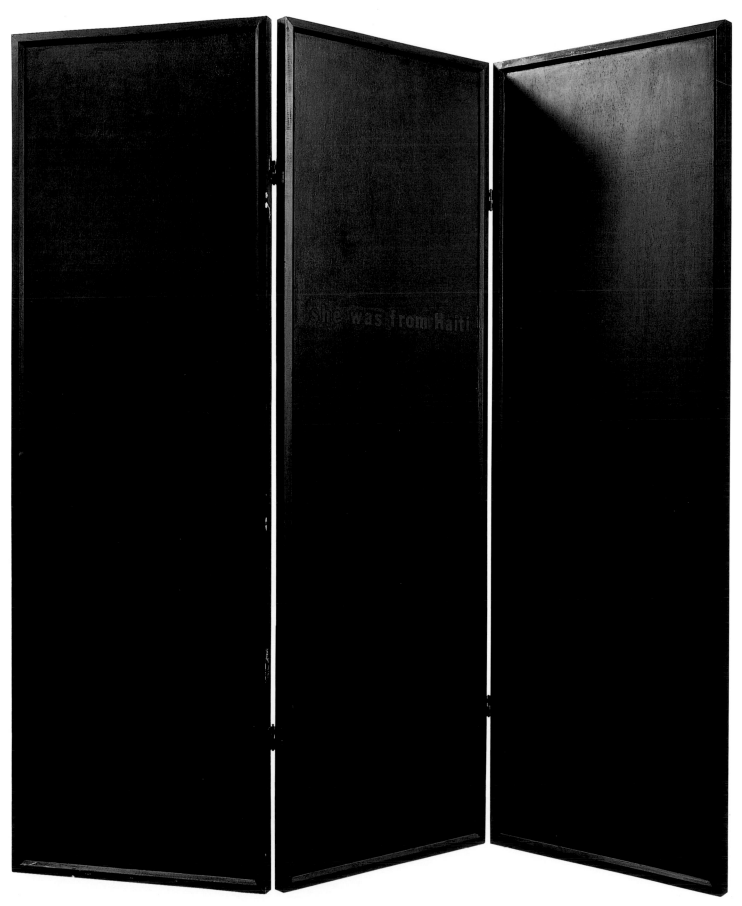

Lorna Simpson, *Screen 1* (back), 1986

SUSAN MEISELAS

BY MELISSA HARRIS

From interviews with Susan Meiselas at her New York studio, March 16 and 27, 1993.

I'm in the middle of this book project about the Kurds. In addition to my own photography, my studio is filled with stacks of images made by men and women I've never met, most of whom died before I was born. Many of these people were strangers—tourists or travelers in Kurdistan, like me, only glimpsing and perhaps not even understanding the history that I—with collaborators around the world—attempted to document.

The last book I helped make drew its central power from the idea that the sustained vision of a group of Chilean photographers during fifteen years of a dictatorship was the clearest and best way to see life in Chile during that period; to put it simply, that book sought to let the world see Chile through *Chilean* eyes. As such, that book seems now very much part of the contemporary debate within photography over who has the right to depict his or her condition or the condition of some "other."

The Kurdish situation has again raised the issue, though differently, for I have found by visiting homes, as well as by going to archives, that without the eye of the "other"—the traveler, the Westerner—there would be few images of the past, and it is indeed those photographs that provide people with a sense of who they have been, in order perhaps to make sense of who they are and who they will be. This experience has reaffirmed for me the value and importance of documentary photography, and at the same time it has made me even more aware of how complex the act of reading meanings from photographs can be. But let me back up and describe how this project began.

Going to Kurdistan was somewhat similar to my travels in Latin America. When I landed in both places I did not really know what I was going to find myself in the middle of. I didn't expect to spend the time there that I have.

What I've learned over fifteen years of working in the field is how to create opportunities out of accidents. I've learned not to be too fixed on what I was supposed to do, to be flexible, and to perceive moments. Sometimes things don't fall into place as you had hoped, and you can stay fixed to one idea or you can see something else that might lead you a little bit off the path.

I first went to Kurdistan with a Human Rights Watch team. Following the Gulf War and the Kurdish uprising in April 1991, Human Rights Watch sent a mission to interview and collect testimony in Kurdish refugee camps just inside the Iranian border, because refugee camps are where you can find a lot of people together—with a lot of time and a lot to recollect. There were reports that four thousand Kurdish villages had been destroyed by

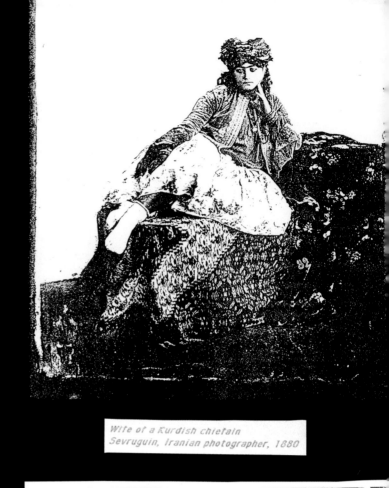

Wife of a Kurdish chieftain
Sevruguin, Iranian photographer, 1880

Qazi Muhammad + map of Kurdistan

Archibald Roosevelt, Asst. U.S. Military Attaché to Teh

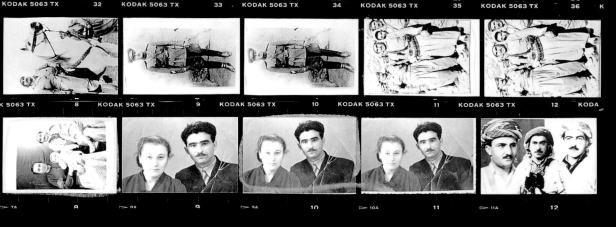

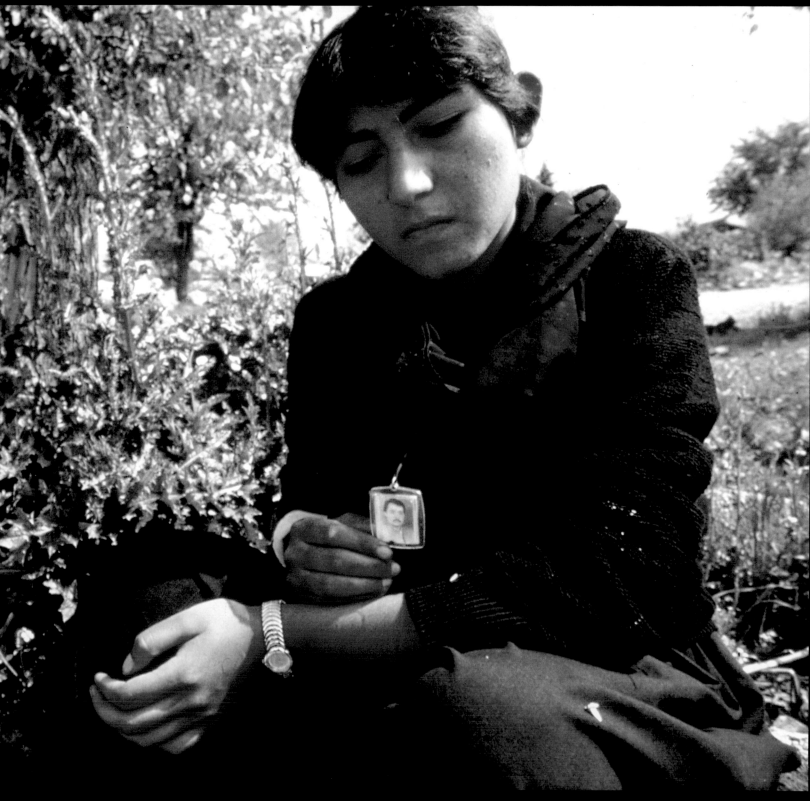

Pages 24–27 and 30–31: Reproductions of Xeroxes and photographs from Meiselas's source books for the Kurdish project

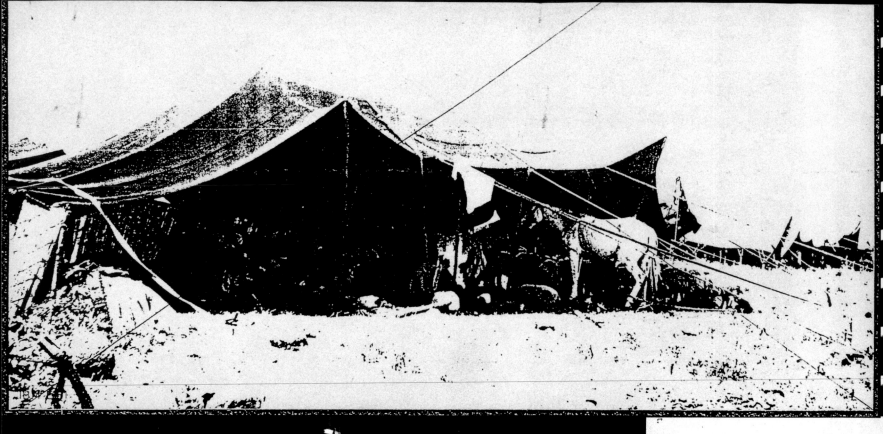

Above: Tents of Kurdish nomads,
Photograph by Robert Montagne, circa 1940.
Below left: Postcard from the 1930s, Iraq
(photographer anonymous)
Below center: Photograph by
Percival M. Sykes, 1912
Below right: Photograph by
Percival M. Sykes, 1912

This postcard sent from a student in Iraq to the Kurdish leader Ibrahim Ahmed asks a powerful question: How can one best fight for Kurdish independence--with a book or with a gun?

Major P. M. Sykes 1912.

A family of Kurds in the Isfarain Valley.

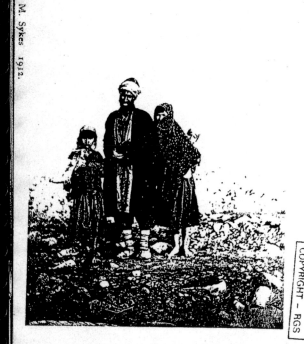

PERSIA

COPYRIGHT - RGS

A Family of Kurds
the Isfarain Valley

Top right:
Susan Meiselas,
Town of Qaladiza
in Iraqi Kurdistan,
destroyed by the
Iraqi army,
April 1991
Bottom right:
Susan Meiselas,
Women doing
laundry in Qaladiza,
April 1991

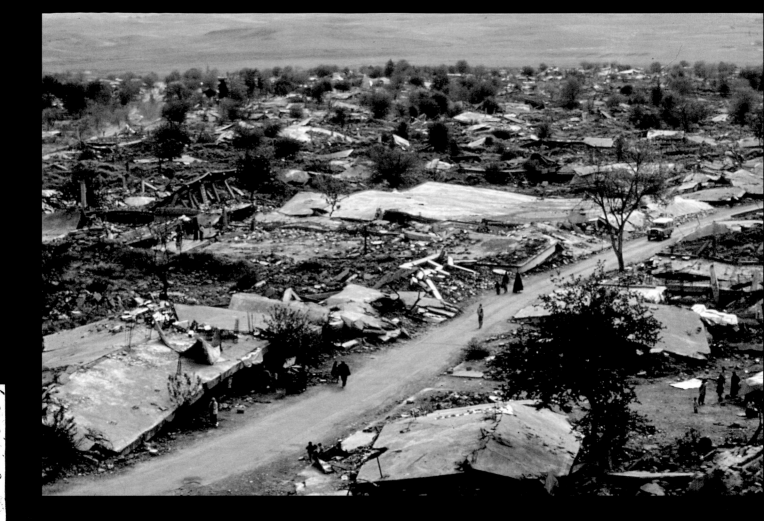

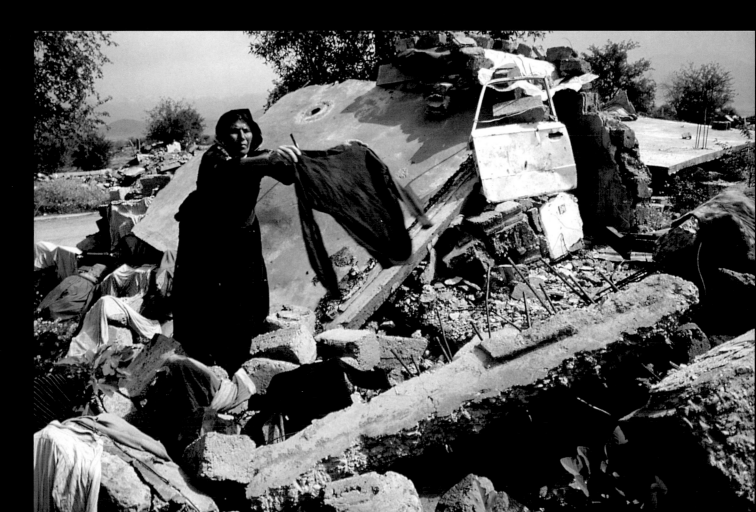

Saddam Hussein's forces. And although Human Rights Watch had published these reports, they didn't have proof, they hadn't seen it, and did not know the extent of what had happened.

For me, on this first trip, things didn't go exactly according to plan. I missed the team in Tehran and could only get a five-day visa to stay in Iran as a photojournalist. I went to the camps anyway, and once there found myself in the midst of an entourage of journalists following the wife of French President François Mitterand, who was scheduled to travel to the border to meet Barzani, the leader of the Iraqi Kurds. While covering that meeting, I met a commander who was willing to take me across the border into the "liberated" zone, where the Kurds had driven the Iraqi military forces out and were beginning to establish self-rule.

For four days I was driven around by four young *peshmergas* (Kurdish guerrillas, literally "those who face death") and I photographed every destroyed village I saw, documented as much visible evidence of what happened, and heard as many stories as I could. We went to Qaladiza, where seventy thousand people had lived before Saddam attacked the town in 1989 and completely leveled it. Now refugees who had fled the Iraqi army in Erbil, Kirkuk, and Sulaimaniya—who were afraid

Susan Meiselas in Rafiq Studio, Sulaimaniya, Iraq, September 1992

to go to Turkey, and who were afraid to go to Iran—camped in the ruins of Qaladiza with absolutely nothing: no water, no electricity, no food, because somehow they felt more secure there.

It was extraordinary. Some people were living under the concrete blocks of their former houses, eating mostly wild rhubarb. Everybody was pitching in, everybody was doing something: somebody was getting firewood; somebody was locating water. They had no help from the International Red Cross. They were like pioneers. There was a very strong sense of community among these people, who had nothing.

I had only five days to get back into Iran before my visa was up, but I think that little journey was when the idea of Kurdistan began to take hold of me. At that point it was not just a place I was visiting; I was starting to be intrigued by—and in some way, I started to feel connected to—what the Kurds were fighting for, and against.

Kurdistan has always been where the Kurds live; but Kurdistan can mean Iraqi or Iranian Kurdistan, the southeast of Turkey, or parts of Syria and Russia. When Kurds say "Kurdistan," they often mean the place—the country—where they are currently living. But they also use the word to refer to a desire. For over one hundred years they have fought for the *idea* of "Kurdistan"; yet the Kurds as a people have never established a nation.

This project is a photographic history of the Kurdish nationalist movement. It's also about the role Western image-makers have played in shaping the West's and the Kurds' own picture of that history. I'm looking at the work of missionaries, anthropologists, military personnel, as well as photojournalists and Kurdish photographers. Some of my own current work will also be included.

While working on the project, my researcher and I constantly came up against the question: "What are these white Western women doing floating around Kurdistan?" The fact is, though, that my own obsession about the ways the West has represented the Kurds is of no interest or use to them now. All they want is to get the West to do what they need done at this moment, which is to recognize some independent, autonomous jurisdiction for Kurdistan. And if photography can help with that, fine.

When Human Rights Watch decided to send Dr. Clyde Snow, a forensic anthropologist, to Iraq to begin to document mass graves, I went along with the team. We had no idea what we were going to find in terms of the evidence of genocide, although we knew something about the Anfal campaign from the testimony of the Kurdish refugees. We were looking for physical documentation, gravesites or any other kind of markings.

We investigated several locations and finally chose the village of Koreme to fully exhume. Koreme can speak for many mass-grave sites—it could be any site. And what was unearthed there will be the basis for the Human Rights Watch genocide case against Iraq, on behalf of those villages, those widows. That documentation is at the center of my own photography there.

I have documented a lot of sites of various kinds of massacres, but never to this degree: this detailed documentation of exhuming skeletons and reconstructing them. During the work in Latin America, we almost longed to find bones—some record—that could tell what had happened at the time of an execution.

But in Kurdistan the Kurds have very strong memories of where the mass graves are—because they were forced to bury people from their own communities. I remember outside of Sulaimaniya seeing one bulldozer digging deeper and deeper and deeper. A man was absolutely convinced that *that* was where he had buried someone—but they couldn't find the bones. He was saying, "I saw them push three men, and they were blindfolded, and their hands were tied behind their backs. I know, I remember it. It was light. They were thrown into a hole . . . it has to be here." And the bulldozer kept going around and around, ravaging the earth—and not finding anything. Digging is very much the metaphor for this entire project.

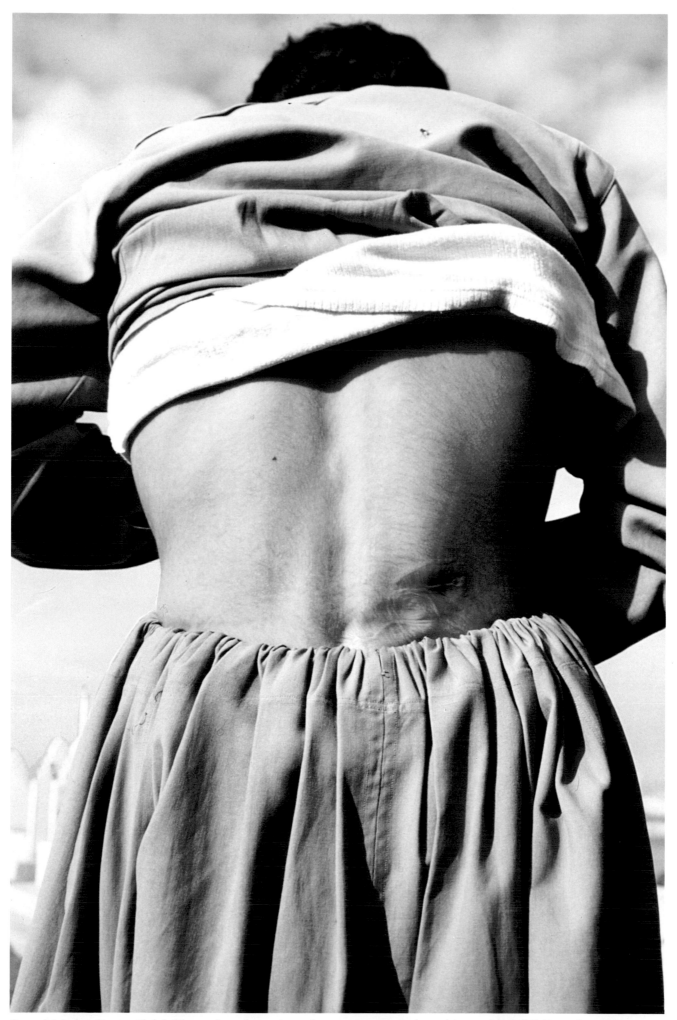

Susan Meiselas, Tamur Abdul, fifteen, the only survivor of a mass execution, shows his wounds, Erbil, December 1991

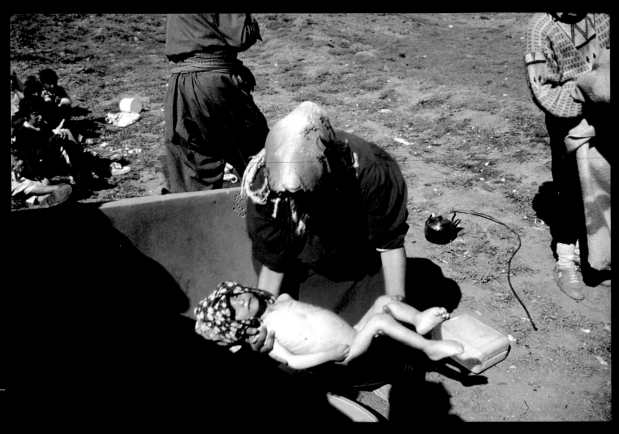

Top: Contact sheet from the collection of Hatow Hamid Majid Othman Pasha, Sulaimaniya
Right: Susan Meiselas, Woman carrying dead child, Haji Omran, April 1991
Bottom left: Anonymous photograph of Kurdish leader Ismael Simko and his forces, 1920s
Top center: Postcard from 1895. Photograph by Abdullah Frere.
Bottom center: Rosy Rouleau, a Kurdish school, behind the *peshmerga* front lines, 1974
Top right: Photos and Western Union telegram by Henry Field, 1930s
Bottom right: Susan Meiselas, Sister sitting with the skeleton of her exhumed brother at Koreme mass-grave site, June 1992

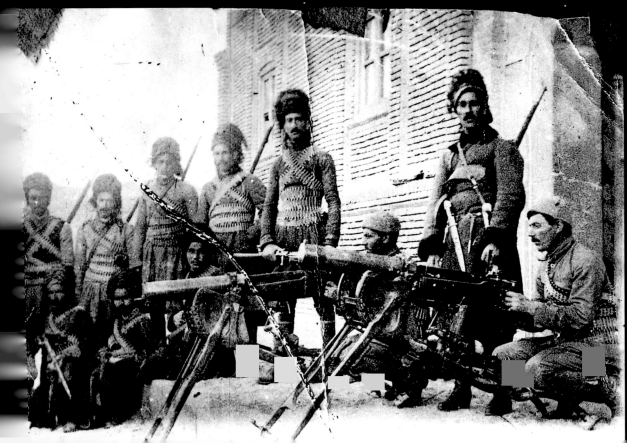

Neg. No. 81366. Kurd male, age 35. Kurdestan, Iraq.

Neg. No. 81367. Kurd male, age 35. Kurdestan, Iraq.

Neg. No. 81345. Kurd male, age 20. Kurdestan, Iraq.

Neg. No. 81346. Kurd male, age 20. Kurdestan, Iraq.

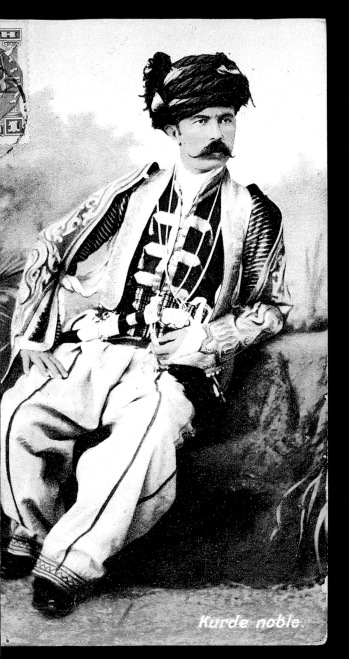

Kurde noble.

THE COMPANY WILL APPRECIATE SUGGESTIONS FROM ITS PATRONS CONCERNING ITS SERVICE

1201-S

CLASS OF SERVICE		SIGNS
This is a full-rate Telegram or Cablegram unless its deferred character is indicated by a suitable sign above or preceding the address.	**WESTERN UNION** (09). R. B. WHITE PRESIDENT NEWCOMB CARLTON CHAIRMAN OF THE BOARD J. C. WILLEVER FIRST VICE-PRESIDENT	DL = Day Letter NM = Night Message NL = Night Letter LC = Deferred Cable NLT = Cable Night Letter Ship Radiogram

The filing time as shown in the date line on full-rate telegrams and day letters, and the time of receipt at destination as shown on all messages, is STANDARD TIME.

Received at 1256 S. Michigan Ave., Chicago, Ill. Victory 5343

1935 AUG 29 PM 2 10

MINUTES IN TRANSIT
FULL-RATE DAY LETTER

CBQ60 48 DL=ANNARBOR MICH 29 217P

HENRY FIELD=

FIELD MUSEUM=

MEASURED EIGHTY ONE WOMEN ONE HUNDRED FIFTY EIGHT MEN TOTAL
TWO HUNDRED THIRTY NINE INDIVIDUALS ALSO I HAVE MEASUREMENTS
OF NINE BAGHDAD GIRLS AGES SIXTEEN TO TWENTY FROM PREVIOUS
YEAR MANY THANKS FOR YOUR MANUSCRIPT WHICH I SHALL BRING WITH
ME SEPT TWELFTH UNLESS YOU WANT IT SOONER=

SMEATON.

Henry Field, Anthropologist 1930's

STAN

STAN

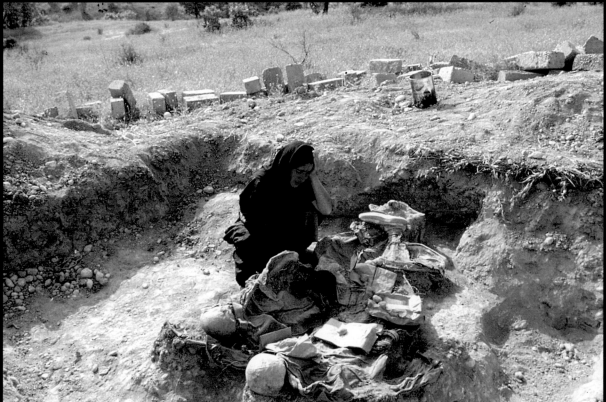

In preparation for the mission, I had been reading whatever I could find about the Kurds. As with my work in Nicaragua—I'd had no previous experience in Latin America—I again found myself in a region where I was starting from scratch. Like most Americans, I knew nothing about Kurdish history. Because there is no single Kurdish state, and no official institution to create a national collection, there's no central archive—such as our Library of Congress. In any library one discovers the Kurds classified either by the countries where they live, or under "ethnic types." Some of the books I read contained a few old photographs from Kurdistan. They fascinated me—and I thought there had to be more. I began searching in international archives. When I headed back to the field I looked in local photo studios for what images remained, and my search eventually led me to family albums throughout Kurdistan.

Having seen only the totally destroyed Iraqi villages, I was curious to know what ongoing life in Kurdish villages was like. The only place where that could be seen was in Iran, where, ironically, though it's a repressive government in a number of ways, the Kurds are able to live with their traditional customs and dress and their tribal structure still intact.

Although this first trip to Iran didn't generate many important photographs for me, it was the first time I really tried to find old photographs in the villages. On the first trip, using a macro lens, I made 35mm black-and-white copy negatives of the photographs I found. I thought that would be efficient, because it would mean carrying just one extra lens with the system that I was already using. I decided to change to larger-format film for better quality, but discovered that the more significant difference was in the intimacy gained from being able to share with a family the process of reproducing their images. Watching the Polaroid positive-negative film being developed in their backyards, they could see the importance of the images that they were contributing, and perhaps better understand the project. Generally, the families who shared their images with us felt that they were participating in a process. In some ways it's surprising that they're willing to share them with total strangers—but "share" is really the operative word. Working with a Polaroid system and positive-negative film has really been critical in building trust.

In the United States one might expect to find snapshots from a family picnic or a graduation; in Kurdistan the most common image is of young men dressed as *peshmergas*. For the makers and keepers of these images, they are testaments to heroism, but they are also evidence of participation in political movements that have been ruthlessly suppressed. Many people talked about the loss of their photographs. When forced to flee as refugees, they couldn't carry their albums for fear they would incriminate their families. Often what was left behind was raided or lost. Some local photographers took a risk, burying their archives. Though family photographs are very precious and irreplaceable, many people had to destroy them to protect themselves.

Assembling the images for the book part of this project has been incredibly exciting, but it has been difficult in ways my co-workers and I didn't anticipate. We have had to work very hard to find images that are *not* of warriors. There is a very subtle separation between the West seeing all Kurds as warriors and the Kurd wanting to be photographed as the warrior because that's the romantic image. To balance out the story, we are working with primary sources such as declassified documents, letters from the grandsons of photographers, as well as with diaries and newspaper reports.

The strong sense I had in Kurdistan was that I was photographing very consciously in the present, thinking about how the past would be seen in the future.

This is not going to be the "objective" history of Kurdistan. Ultimately, it is a selection of what has been photographed, and maybe it can, at best, point out what *hasn't* been photographed. This book assumes that one set of protagonists are the image makers. Then there are the protagonists of history, the "players," the importance of whom I often discovered through seeing their photograph over and over. I had to ask, "Why is this man imaged over and over again?" Obviously, he was important at a particular time. But the interpretation of his role in the larger struggle, or even at that particular time, can vary considerably among the Kurds—whether they think he is significant to the shaping of history or not. I don't have the right to decide this. Our project can only be based on what we've been able to find. But we hope to contextualize this material and also to reveal what is missing from Kurdish oral history.

As far as the effect our project may have, at best, it will provide fourth graders in Kurdistan with their own visual history. Today, they don't know much about it. Many of them don't know more than what their fathers have told them—if their fathers knew. In Turkey, for example, Kurdish history is completely omitted from school curriculums—its very existence is generally denied. I also hope this project will raise consciousness in the West, offering people here an opportunity to learn of Western participation in, and influence on, the history of the Kurds.

In order for a Kurd to have undertaken this project, conditions within the region and even inside of Kurdistan would have to have been different. It would have demanded a kind of unity and freedom that the Kurds don't have. We are going across borders that they cannot pass as easily. Also, as an outsider who is a guest, you cross class boundaries—and political boundaries—in a way that insiders can't. But the most sensitive part of this work is not becoming involved: maintaining oneself as an outsider, as much as one might desire at times to be inside.

We're dealing with a history that no single Kurd has ever lived. We want as much as we can to allow all of those Kurds in competing histories to be represented and to be revealed by representation. Do the Kurds connect to a sense of the history that we've been uncovering? The reality is that they must still be digging for their own, much more immediate history—which is tragic.

In the Shadow of History: Kurdistan, a Photographic History of the Kurds from the 1880's to the Present is a collaborative book project that will be published by Random House in 1994.

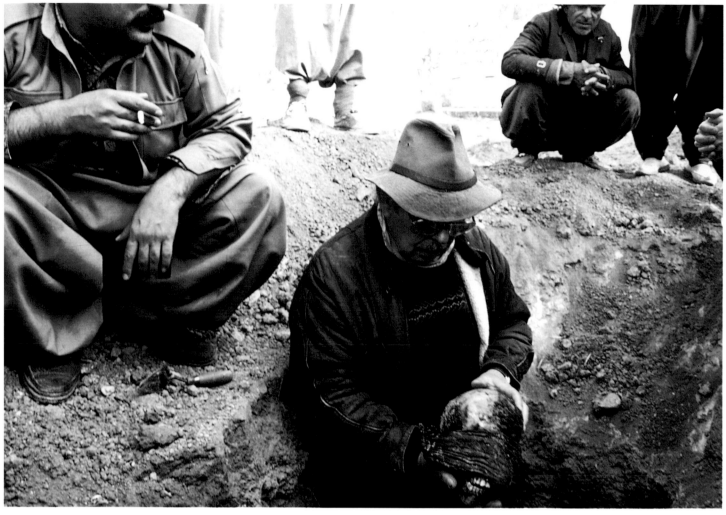

Susan Meiselas, Dr. Clyde Snow, forensic anthropologist working with Human Rights Watch, holds blindfolded skull of an executed male teenager estimated to be between fifteen and eighteen years old, December 1991

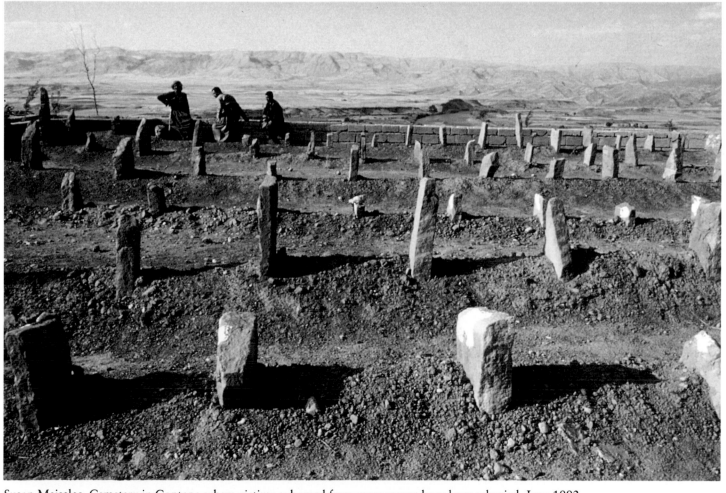

Susan Meiselas, Cemetery in Goptapa where victims exhumed from mass graves have been reburied, June 1992

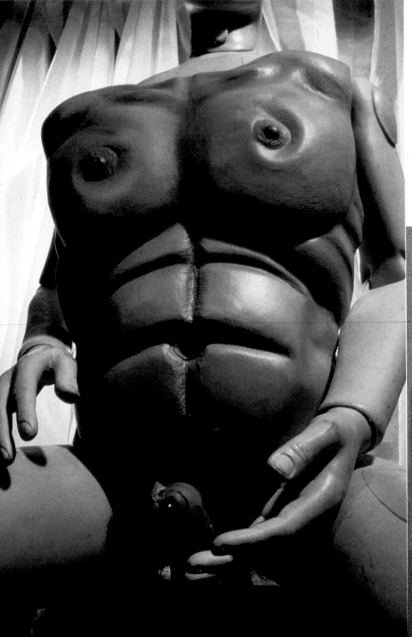

CINDY SHERMAN

BY DAVID GOLDSMITH

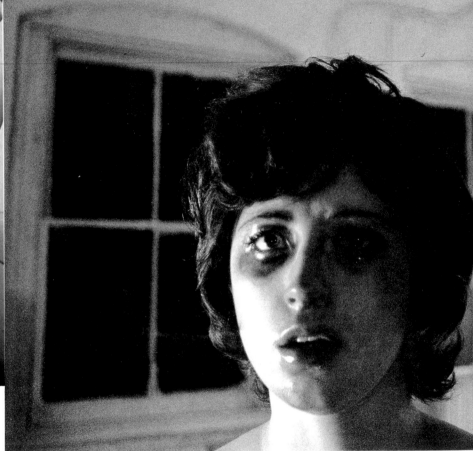

From interviews with Cindy Sherman at her New York studio, kitchen, and living room, March 18 and April 6, 1993.

When I'm cooking, I'm just following a recipe—I'm being told what to do. When I'm working on my photographs I have to make up my own sort of rules. Sometimes I have a vision of what I want but mostly I'm guided by what I don't want. I'm happy to make mistakes; making photos is more like playing than cooking is. I wouldn't want to eat what I made just playing with cooking ingredients, but sometimes the mistakes in the photos are better than what I had in mind.

I sort of imbue the mannequins with a karma. Sometimes the subliminal comes through, and maybe that's why some people think these pictures are funny.

I did a few like this (above) around 1979. The place I was living in was very dumpy, and it inspired a lot of crazy characters. I don't remember if I was thinking of a specific film or was just looking for a new direction. It is unlike any of the other black and whites.

I think that the way these pictures come through me is mostly intuitive—unless I have something specific in mind, like with the sex pictures; I definitely had ideas of what each one was about. But I don't title them. I'm not going to thrust the issues in my work into people's faces with words.

Above left:
Cindy Sherman,
Untitled, 1992

Above:
Cindy Serman,
*Untitled Film
Still*, 1979

Opposite:
Cindy Sherman,
Untitled, 1992

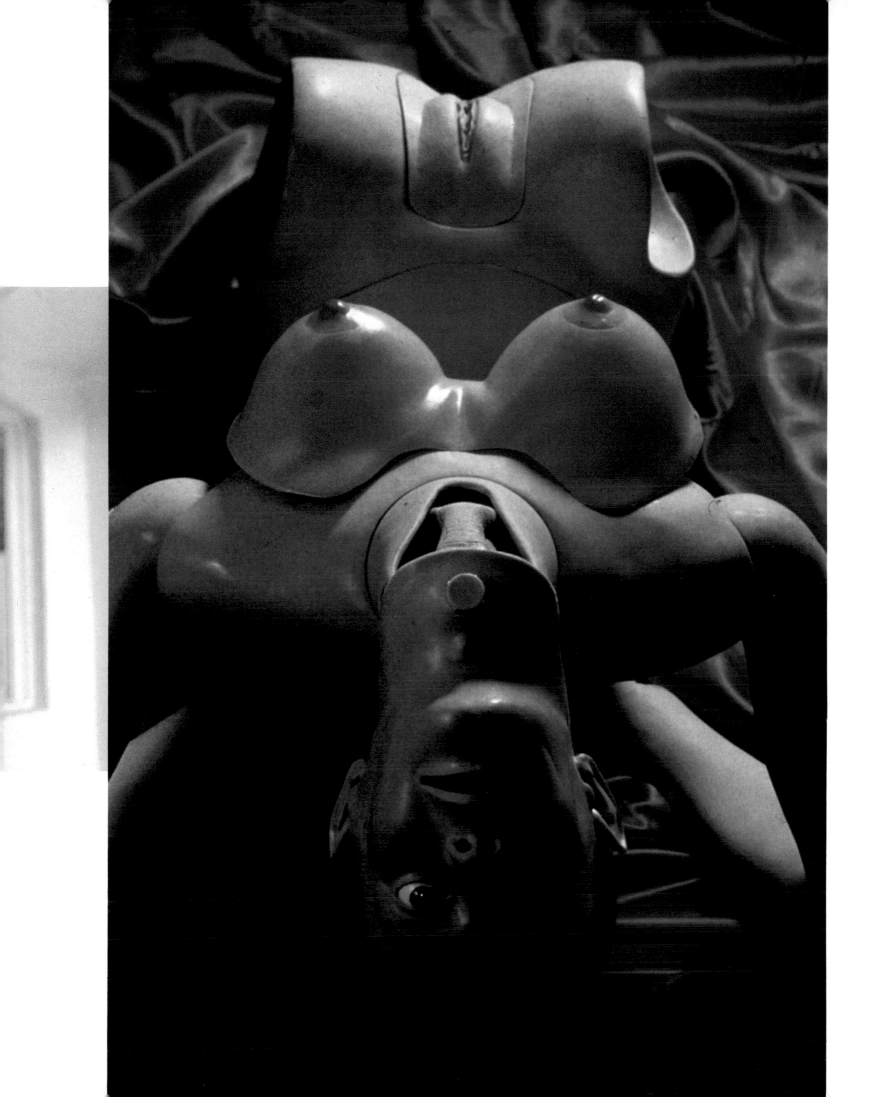

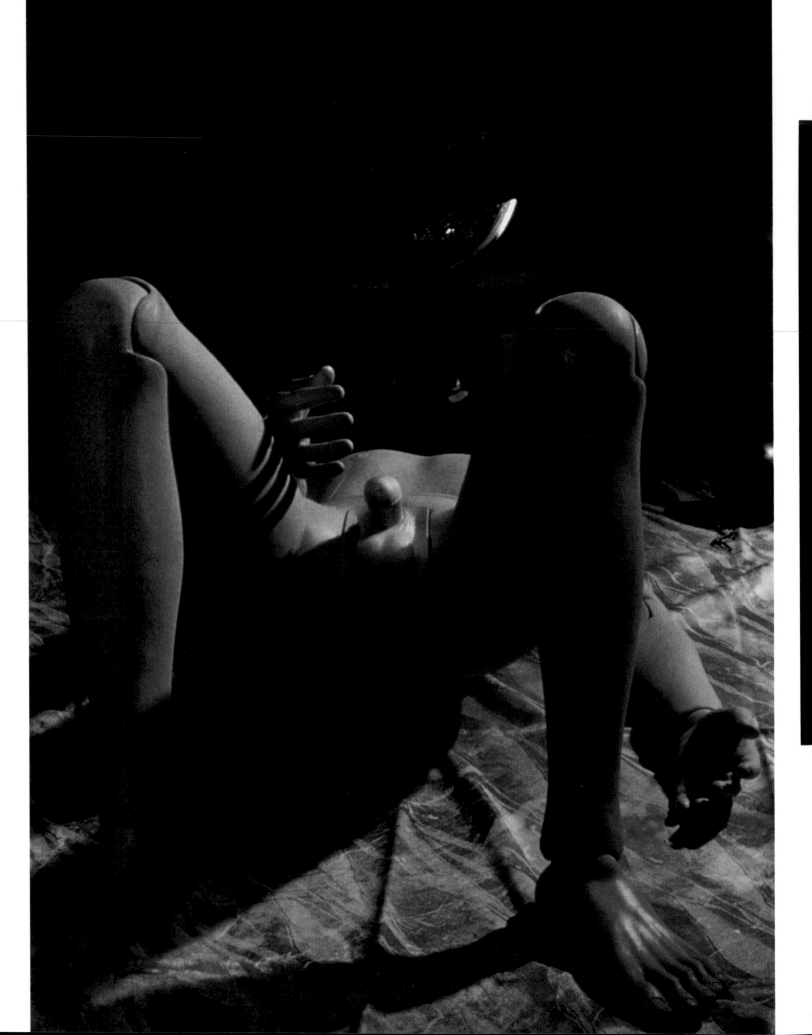

When I started working on this sex series (left) I would be within a female character and do the most basic female sex take-off shot. Then I did a male version of it. As the series progressed, I started taking the bodies apart more and more and so they got more . . . disjointed. Oh dear! Deconstructed.

This (above) is just a close-up of a deflated head with eyeballs. It's from experimenting with some toys I've been buying, from a series called "The Mad Scientist." Some of them are little skeletons that you put monster flesh on and then boil off. This one is a balloon contraption that you pump up to a certain size and cover with fleshy stuff. After that you can either deflate it or inflate it to distort it.

I was afraid that being happy would diminish my work. I'm generally someone who likes to be happy and find the positive side of things. But not in my work. To drive my work, I've gone beyond my earlier money and relationship struggles to other struggles in the world, but I still use personal fears to keep my work moving. I wanted to do some happy and nice pictures but I found I could only show the underside.

Above: Cindy Sherman, *Untitled*, 1987–91

Opposite: Cindy Sherman *Untitled*, 1992

As long as I have a mirror next to the camera, I'm acting enough to go into a kind of trance and draw a character up. I have little scenarios in my mind. What is difficult about not being in certain pictures is that they are less spontaneous. I can't rely on creating the perfect moment through my acting; I have to push harder. I have to make the inanimate objects look like they are alive.

When I stuff envelopes I try to figure out the best, most efficient system. I could get obsessive about gardening if I let myself. My neighbors upstate are much more carefree—without rhyme or reason, the same spacing for the beans and tomatoes. I do, in a way, have intense concentration. I get my household superorganized before I make my photos. And then I throw things around and don't care.

Video stills of Sherman at work

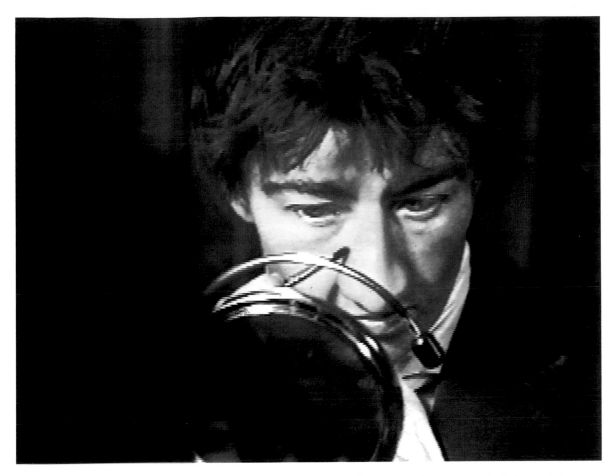

The way I see it, as soon as I make a piece I've lost control of it.

I've just started to learn how to do things on the computer, like taking somebody's head off and putting it on top of someone else's body. Little operations like head transplants. Using the computer can be like drawing or typing—an obsessive action that you do with your hands. I'd been thinking of it as a way to fix technical mistakes.

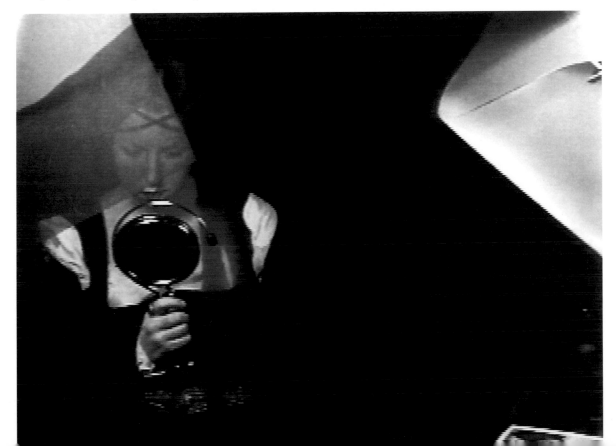

This is one of the first fashion shots (right). The whole series was fun to do because the clothes were really eccentric. In this case it wasn't the sweater dress that was so amusing, but the earrings that were so goofy.

To take this picture (above), I was lying next to the vomit, just outside the picture frame. All I had to do was look in the sunglasses. If I could see the camera I knew it could see me. But it was luck that the clouds I had projected behind me came through so well.

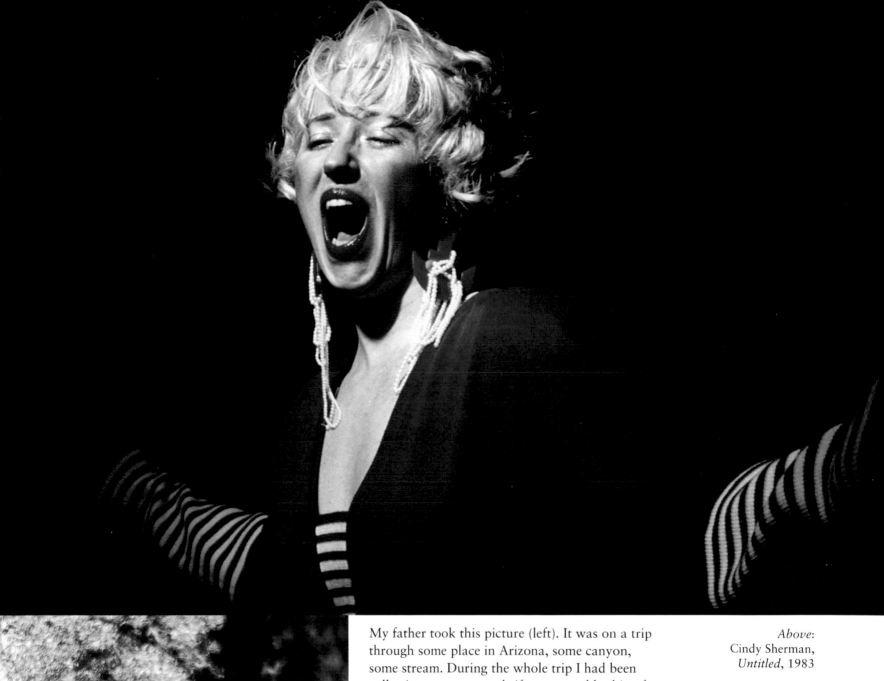

My father took this picture (left). It was on a trip through some place in Arizona, some canyon, some stream. During the whole trip I had been collecting costumes at thrift stores and looking for locations. I had set up my camera using a heavy telephoto lens I hadn't used much before and the whole tripod fell over while I was running down to the stream. When I signaled to him to take the picture I didn't know it had been accidentally put out of focus. Dear old Dad.

I've had to learn more and more techniques. I've never felt while I was creating a series that I was limited by my technique, but afterward I have seen that I wanted to create something that I couldn't. So the next series might be partly about solving those technical probems as well as a political agenda or the lack of a political agenda.

Above:
Cindy Sherman,
Untitled, 1983

Left:
Cindy Sherman,
*Untitled Film
Still*, 1979

Far left:
Cindy Sherman,
Untitled, 1987

Page 42:
Cindy Sherman,
Untitled, 1989

Page 43:
Cindy Sherman,
Untitled, 1992

41

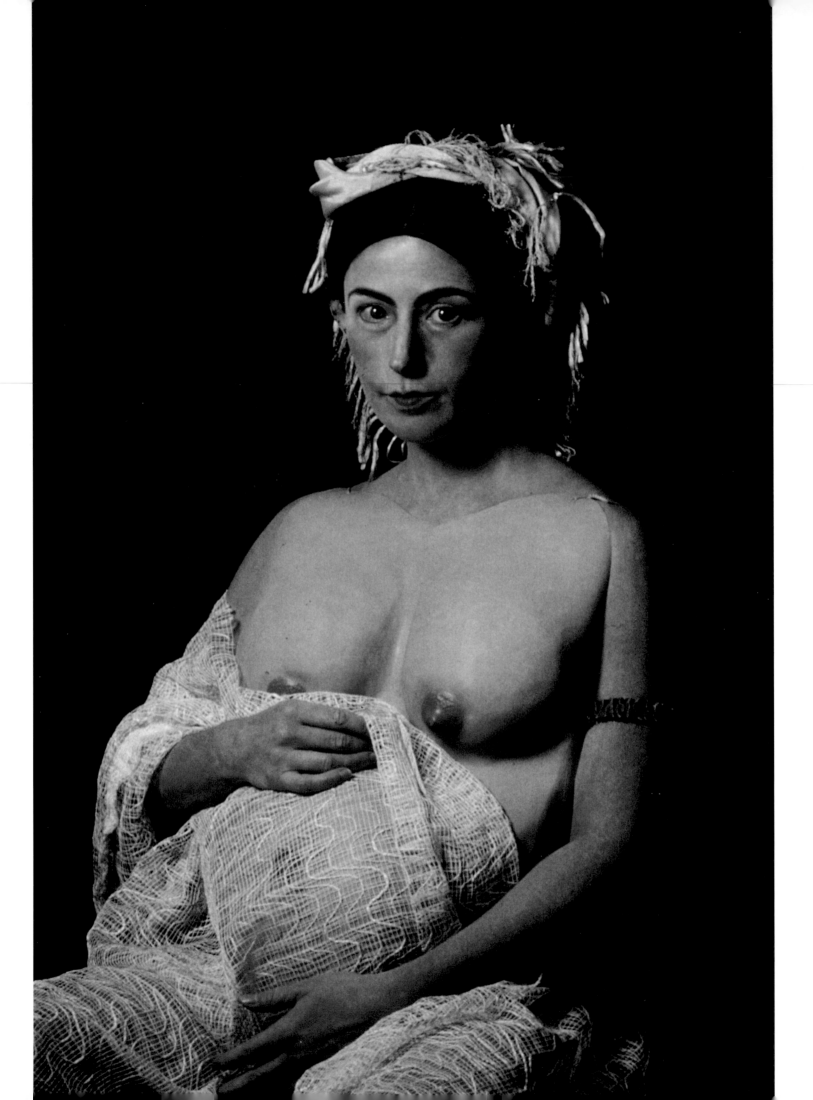

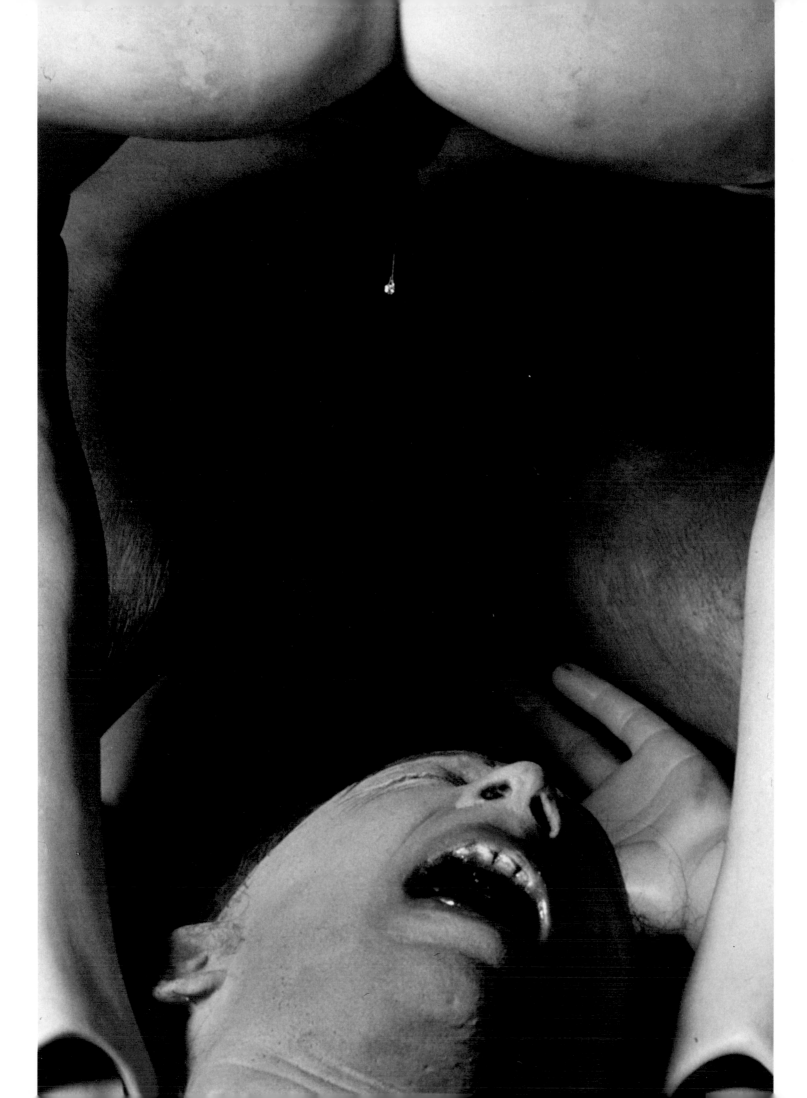

ADAM FUSS

BY MICHAEL SAND

The industrial-strength metal door opens into a dark, cluttered room, which leads to a larger, windowless warehouse space that is Adam Fuss's studio. Although his current work involves laying fresh rabbit intestines on photographic paper for extended periods of time, the air reveals nothing other than the smell of photo chemistry.

The front room contains an aging refrigerator, a large table on which rests a work-in-process (tightly wrapped in black paper), and a wall of metal bookshelves holding Fuss's "library": a Ralph Eugene Meatyard monograph, Joan Mitchell's book of pastels, *The Art of Photography*, and a hodgepodge of assorted catalogs and magazines. Somewhere in the mess of papers and books is a copy of Paul Caponigro's out-of-print sunflower monograph.

In the rear of the studio a monstrous, spiderlike contraption made of garden hoses and metal piping hangs from the ceiling. It is a device Fuss built to create a sheet of falling water for a series of images he plans someday to make. This gnarled sculpture takes up a fair amount of room, and was one reason he rented the warehouse to begin with. Fuss is an incurable experimenter.

A black form lopes around the studio. A cat? No, it's Jacob, Fuss's beloved pet rabbit. This is not a sick joke; he does not plan to eviscerate the creature for some future project. And as we talk, Fuss takes Jacob on his lap and strokes the rabbit's long ears lovingly.

Over a year ago, at a time of wrenching emotional turmoil in his

Adam Fuss, sketch from "Details of Love," 1992

life, Fuss began "Details of Love," a recent series of images. The work that was the prototype for this project is a color photogram depicting two rabbits in profile, face to face, surrounded by a luminous multicolored tangle of abstract squiggles. It is called, simply, *Love*. The squiggles that are the basis of all the images in this series are rabbit intestines; the painterly depth and range of colors are the result of an unlikely chemical interaction between the fresh innards and Cibachrome paper.

Fuss's peculiar form of personal expression begins to make sense when his art is viewed in retrospect. From this angle, "Details of Love" can be seen as the "natural" product of a decade of relentless technical photographic experimentation—from his haunting early pinhole photographs, taken in museum galleries after hours, to near-invisible portraits of children that slowly emerge from a pitch-black background, to unique color photograms often involving organic materials.

Fuss was first drawn to photography at school in England in the 1970s. "I was attracted to photography because it was technical, full of gadgets, and I was obsessed with science. But at some point around fifteen or sixteen, I had a sense that photography could provide a bridge from the world of science to the world of art, or image. Photography was a means of crossing into a new place that I didn't know."

He was intrigued early on by a demonstration of the possibilities offered by the pinhole camera. Its sheer simplicity convinced him that good pictures, truly imaginative pictures, resulted from

Below: Adam Fuss in his studio, 1993. Photograph by Nick Waplington.

Opposite: Adam Fuss, *Untitled*, 1985

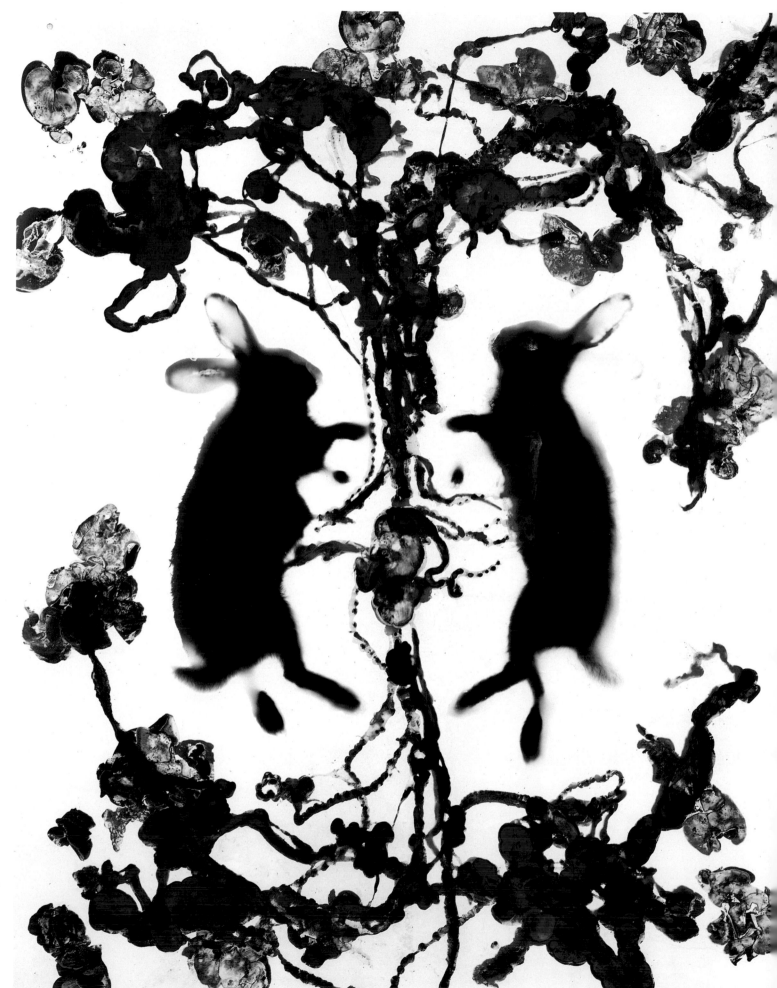

Right:
Adam Fuss,
Love, 1992
Opposite:
Adam Fuss,
Untitled, 1992

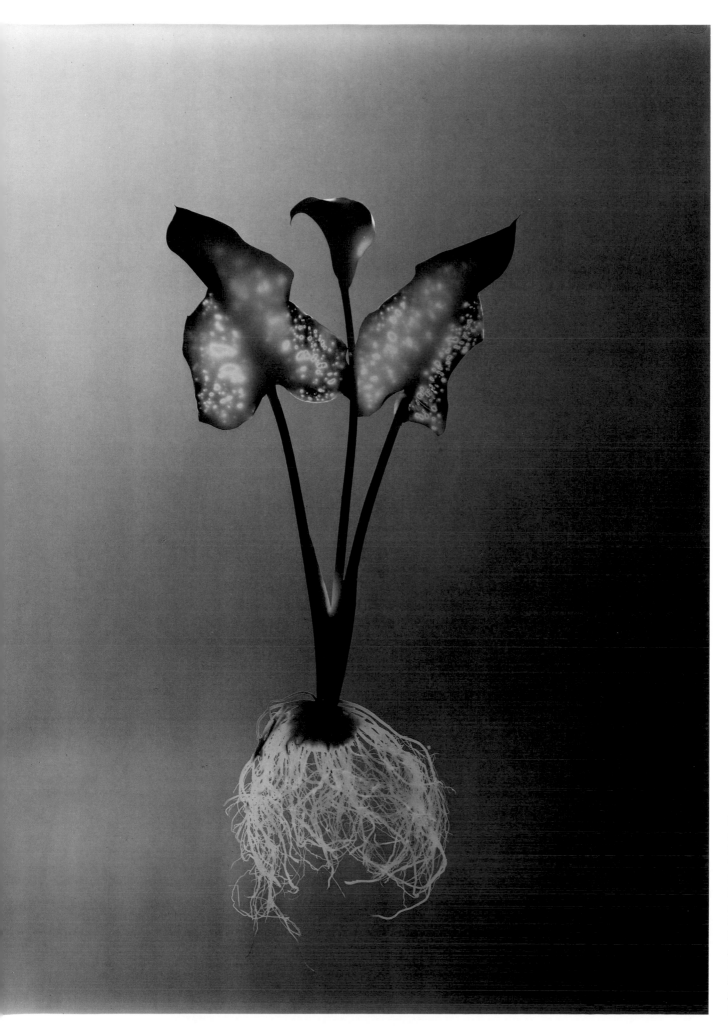

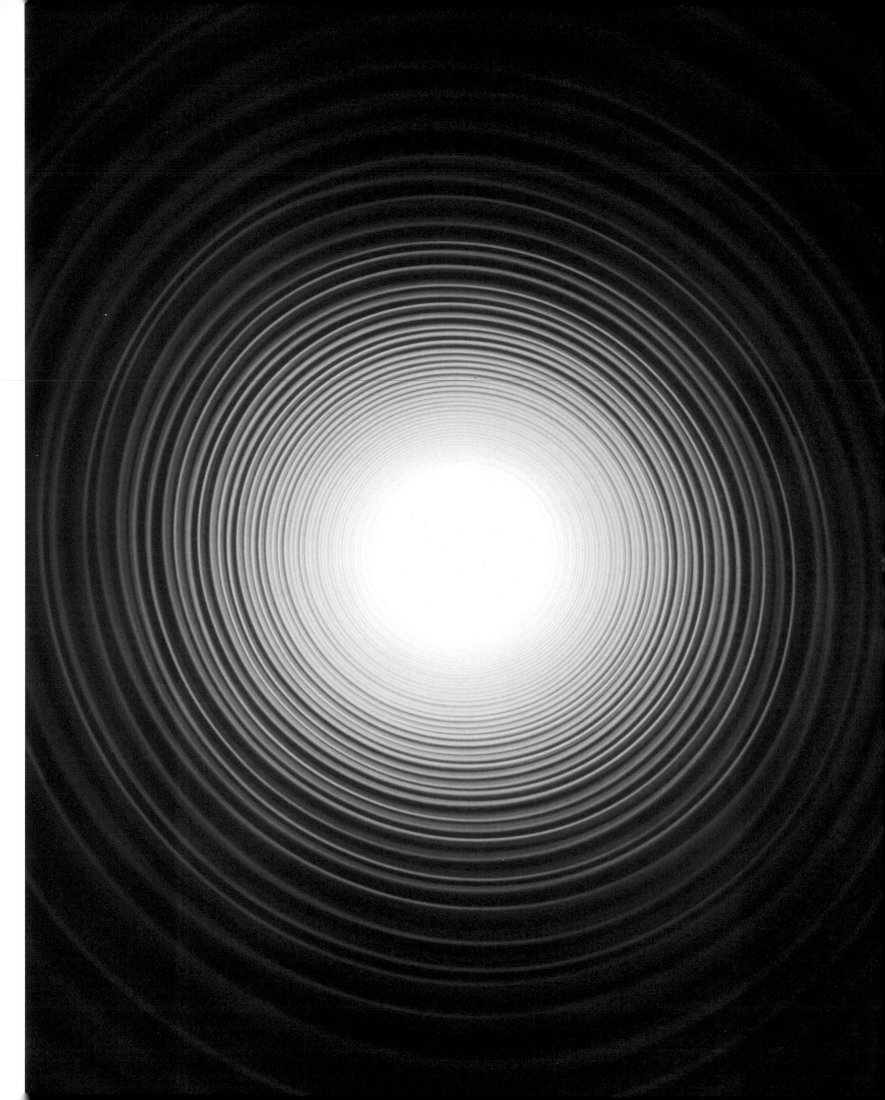

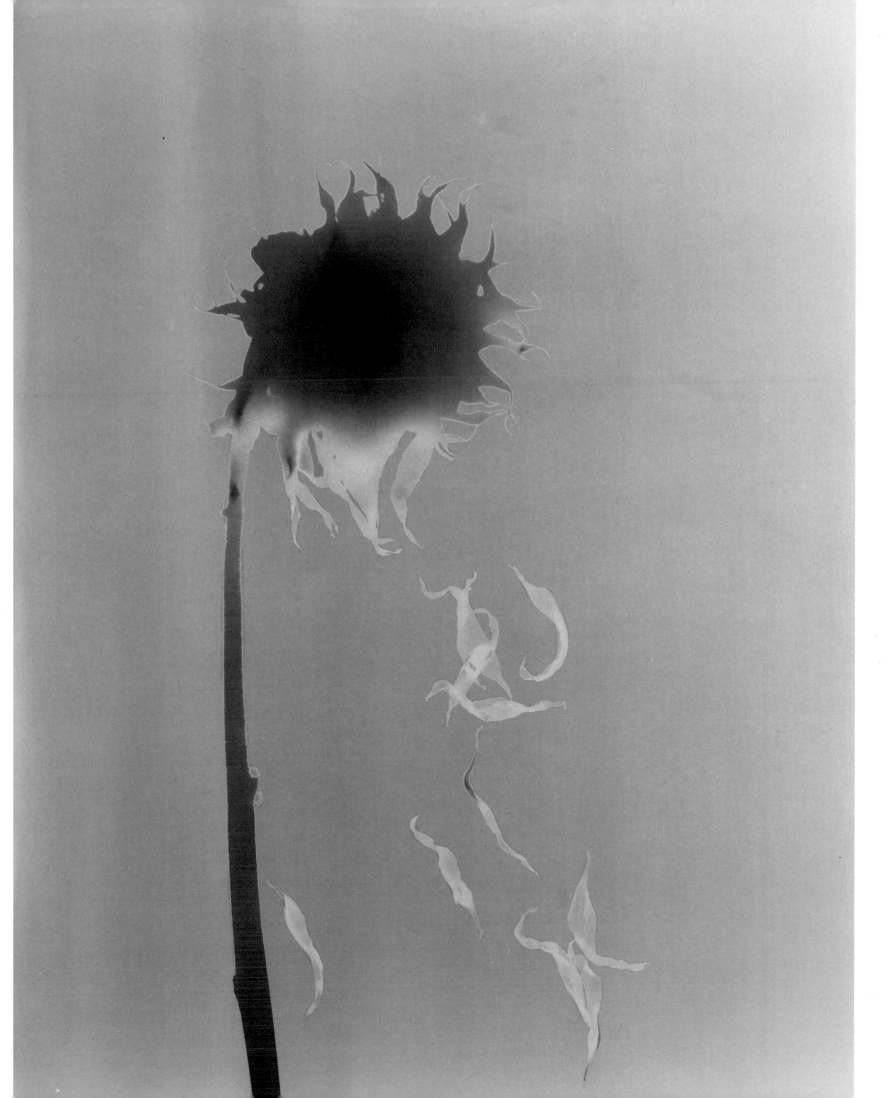

the creativity of the photographer, not necessarily from the sophistication of the equipment.

As Fuss describes it, his progression from the single-lens-reflex to the pinhole camera to the photogram was a process of gradual internalization—of the outside world coming closer to the film plane and the film in turn insinuating itself into the artist and his subjects. In a twist on Christopher Isherwood's famous "I am a camera," Fuss sees his "Details of Love" as being "inside the camera, but also, I feel, inside my body. . . . It's not literally medical photography, but the subject matter derives from a sort of internalness. Yes, it's also taking place inside this dark space."

Asked if he consciously set out to explore cameraless photography, Fuss reacts with an almost knee-jerk negative response. His first photogram, he insists, was the result of an accident. While Fuss was taking a pinhole photograph using a homemade cardboard-box camera, the opening that served as the camera's lens was accidently closed off. However, light leaked in from a corner of the box. It struck the color film at a sharp angle, resulting in a graduated color field dotted with the elongated shadows of dust particles floating around the interior of the box. Since there was no lens, strictly speaking, Fuss regards the image as his first photogram. "Light played across the film. . . . When I processed it, I saw this world, this other world of image that I was unaware of. And that showed me that I didn't need the camera any more."

Soon after this discovery he began placing a variety of objects directly onto Cibachrome paper and exposing them to light: brightly colored balloons, which allowed some light to pass through them; the yolk of an egg; long, wiry fiddleheads; sunflowers, in full glory and in various states of decay; stained glass—the list goes on. He also made photograms of movable subjects: psychedelic spirals of light created by swinging a flashlight from a pendulum over photosensitive paper, snakes slithering through sand, and babies in pools of water. Fuss claims that all of these experiments are still in a process of revision and refinement.

As with the very first photogram, chance is partly responsible for Fuss's current work with rabbit intestines. During the creation of one of the snake images, the reptile's bodily needs took over and it relieved itself onto the Cibachrome paper. When Fuss developed the print, he discovered that the snake's fluids had caused a chemical reaction with the agents on the photo-sensitive paper, which resulted in a brightly colored stripe in the middle of the image. From here it was a small leap to experimenting with other organic materials interacting with the photo chemistry. A gutted fish laid out on Cibachrome produced compelling results. It was not long before he began to wonder what photograms of the internal organs of a mammal would look like.

"The rabbit was the perfect animal," explains Fuss, "because it's a creature that absorbs a tremendous amount of symbolism—reproduction, fertility, sacrifice, innocence." And rabbits are also fairly easily obtainable. "It's very hard to get the intestines from a mammal," says Fuss, "unless you want to get a sheep or a goat and slaughter it yourself." He could get his materials from laboratories, such as those that supply medical schools, but he finds that the chemical process in his work requires that the innards be fresh. A steady reserve of rabbit intestines from a local restaurant supplier allows Fuss to continue his work.

In order to get the desired effect, Fuss experiments with laying the intestines on photographic paper for varying lengths of time—from a few hours to a full day and night—often moving them around in the dark. The whole setup is then exposed to a flash of light from a hand-held strobe. The longer the "guts" (this is how Fuss generally refers to his working materials) lie on the paper, the more they eat into its surface, destroying the emulsion. Where they have been on overnight, the image is pure white, with the faint outline of the intestine. Where they have been on for only a few hours, a Technicolor impression results.

An intensity backs Fuss's gaze as he talks about the motivations behind his current work. Describing *Love*, he alludes alternately to its emotional underpinnings and to his intellectualized artistic reaction: "There's a quality of line that's figurative, and a quality of line that's abstract, and I wanted to make a picture where these two worlds were joined, in an intimate way. . . . It came initially from this tension between inside and out, and the place where these things converge."

Part of the appeal of the photogram for Fuss is its directness. The objects depicted came into physical contact with the very paper on which the final print appears. The experience is somehow more tactile, and in the case of Fuss's recent work, more visceral. The photograms that involve plants and animals seem not to depict—they invoke the moment of photographic creation, and the life of the organic material, with an eerie immediacy.

Fuss has several projects in development, at least in his mind, at any one time. And he frequently will previsualize complex, seemingly accidental images to a remarkable degree. His next project, he says, will be a photogram, or series of photograms, involving a skeleton, a reflective metallic circle created by a special print-toning process, a butterfly, and an egg yolk. He pictures the skeleton and the butterfly having an ephemeral, distant quality, and the egg yolk a vibrant yellow. "You have the dead body, in the dark, lunar realm, and the passage of the soul, which is represented by a butterfly. And you have this kind of rebirth or reunion, symbolized by the egg yolk." Referring to his own role in the process, he asserts: "Adam is really just bringing these things together. He's not making the materials. The materials already exist. Adam is just a catalyst, or an agent."

> The photograms that involve plants and animals seem not to depict—they invoke the moment of photographic creation, and the life of the organic material, with an eerie immediacy.

Adam Fuss, *Untitled*, 1992

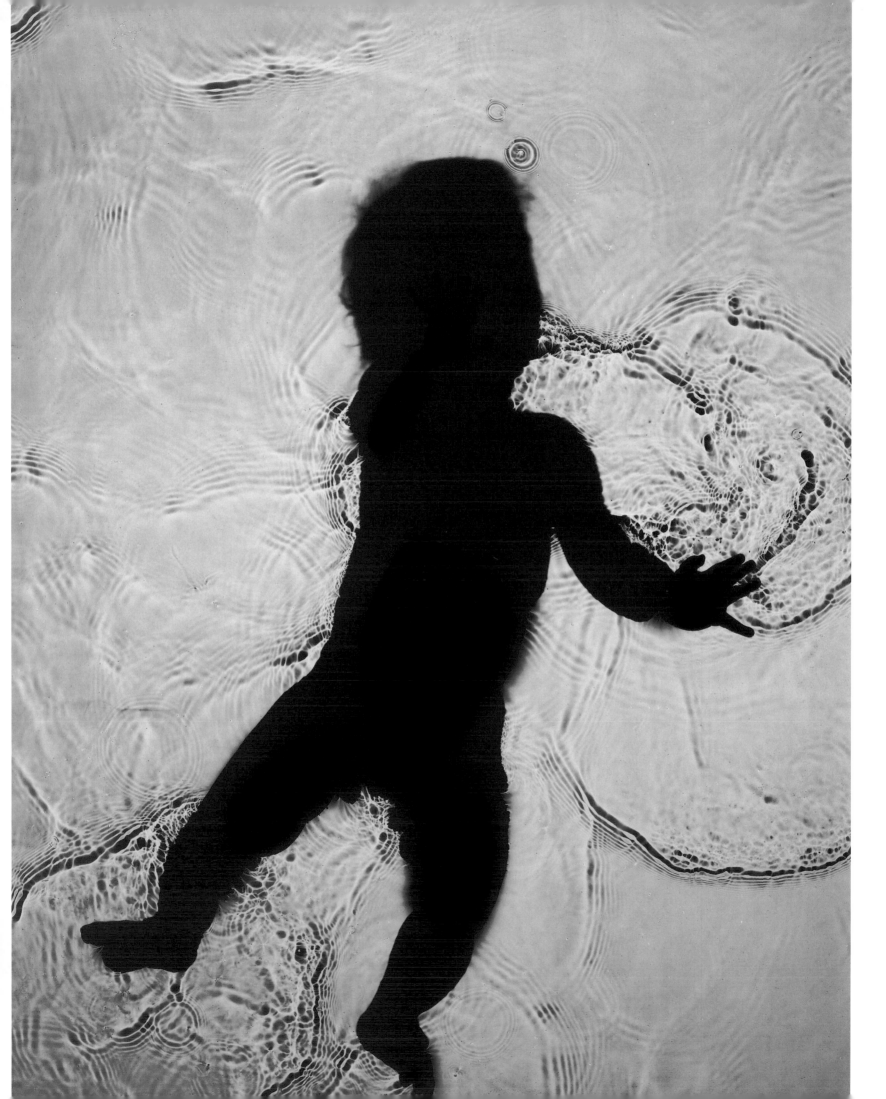

JOEL-PETER WITKIN

BY R. H. CRAVENS

*The theater of grand emotions...
requires the great romantic
repertory.* —Jerzy Grotowski,
Founder, Polish Laboratory Theater

Two actors; two-score dwarfs; a pre-
fabricated, photosculptured stallion
rampant; one-half slaughtered white
cow; sundry lunatics and their keep-
ers; a Mercedes-Benz full of French
filmmakers; a drum; a yoke of flow-
ers; the mask of a youth; a kingly
costume composed in aluminum foil
and cardboard; a power stick; a stair-
case; an abandoned, toiletless factory;
a palace modeled on Versailles; sulfur
hot-spring baths; three insane asylums.

These are among the elements Joel-
Peter Witkin, photography's master
of mise-en-scène, attended to in the
July heat of Budapest as he created one
of the most ambitious images of his

Joel-Peter Witkin in his studio, 1993

New Mexico. It is located about a
mile from the Rio Grande in one of
Albuquerque's mishmash neighbor-
hoods of mobile homes, stables, tract
houses, hay markets, garages, small
manufacturers, and the occasional in-
stance of original architecture. Within
this polymorphous setting, Witkin's
eleven-acre enclave suggests the well-
kept home of a French country gentle-
man. The trimmed, circular lawn is
dominated by two lush, mushroom-
shaped catalpa trees. In the perpetual
shade underneath their branches,
curved and entwined like vaults of a
small chapel, wander brilliantly plum-
aged poultry, and elsewhere—corraled
or lazing in the sun—are four horses,
five cats, and seven dogs. Most of
these animals are "rescues" (one dog
and one cat are amputees) saved from
abuse, abandonment, or euthanasia.

working life. He sent into collision his adaptations of two Renais-
sance masterpieces: Velásquez's *Philip IV, Equestrian* and Titian's
Rape of Europa. Faithful to his sources, heedful of his own psychic
imperatives, Witkin implants such associations as Francis Bacon
and an echo of Picasso. His purpose is a unitary image that imparts
instantaneous ideological, emotional, and spiritual comprehen-
sion emerging from a maze of visual signifiers, metaphors, and
puns—a veritable Chinese box of allegories within allegories.

"As I grow older and evolve aesthetically, the work grows more
complex," says Witkin. "It can't get any more difficult."

Although he photographs almost exclusively indoors, more
than half of Witkin's images are made on location, usually in
France and Mexico. "The reason I work in Europe and other
countries is that visual associations are embodied within their
history. I'm lucky enough to find people who help me, speak the
language for me. And when I return I can share what I pick up
consciously and unconsciously: all the angst, all the unknowns that
emerge in the discovery of creating an image."

Witkin's preparations for Hungary began in his studio in

Flowers are profuse, including an elegant bed of roses, and a
flagstone walk meanders between hedges and under sturdy iron
trellises toward patios and white-stuccoed living quarters. The
Witkin household consists of his wife, Cynthia, an expert practitio-
ner of the ancient art of tattooing, their son, Kersen, who attends
a private Catholic school and who, at fourteen, towers over the rest
of the family; and Barbara Gilbert, a gifted healer of maimed
animals and languishing plants. Witkin's home exudes health and
sanity, but any sense of serenity ends at the door of his enormous,
whitewashed, and skylit studio.

Like most artists of later middle age reaching heights of both
artistic power and public response, Witkin is a driven man. Time
is, if not the enemy, a relentless adversary. Walls and cabinets in the
studio are posted with sketches and worked-over Xeroxes of
favored paintings destined for future photographic projects. An
intriguing drawing blueprints electrical circuitry implanted in the
back of a male torso, which, photographically, will require a

Joel-Peter Witkin, *La Serpentine*, Marseilles, 1992

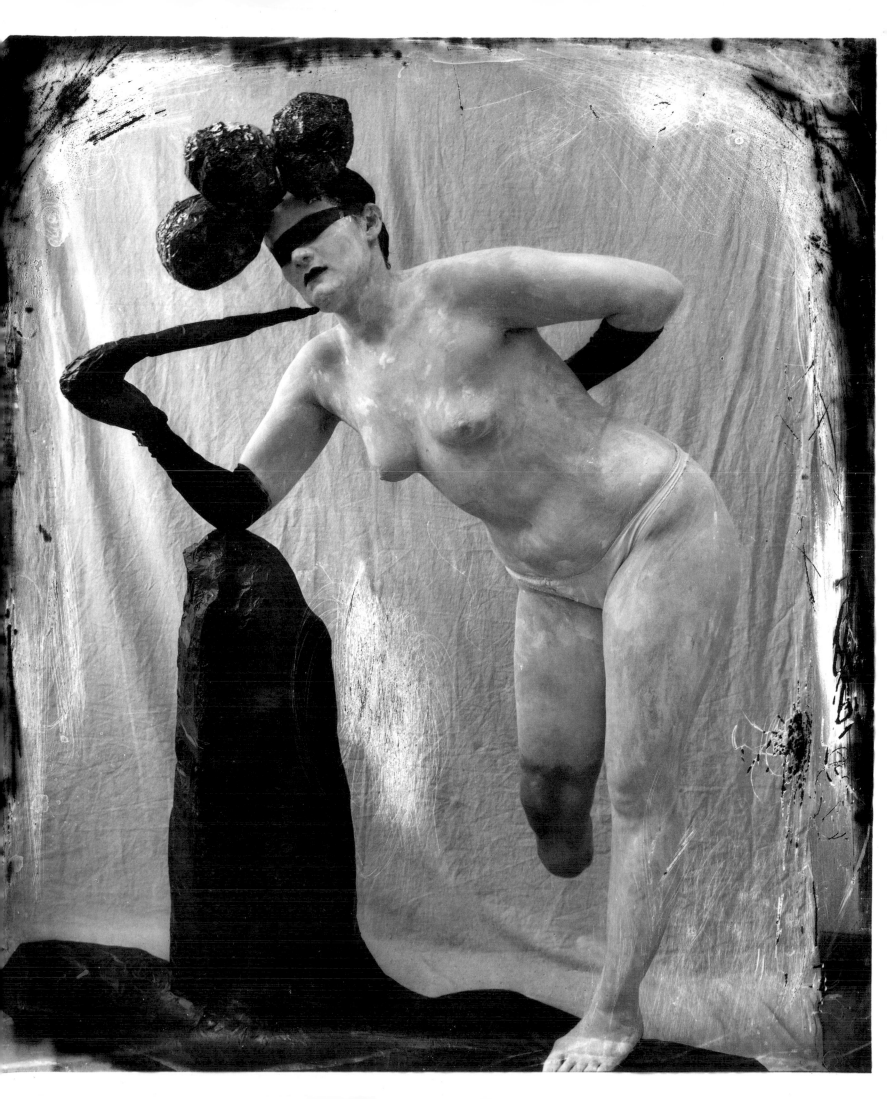

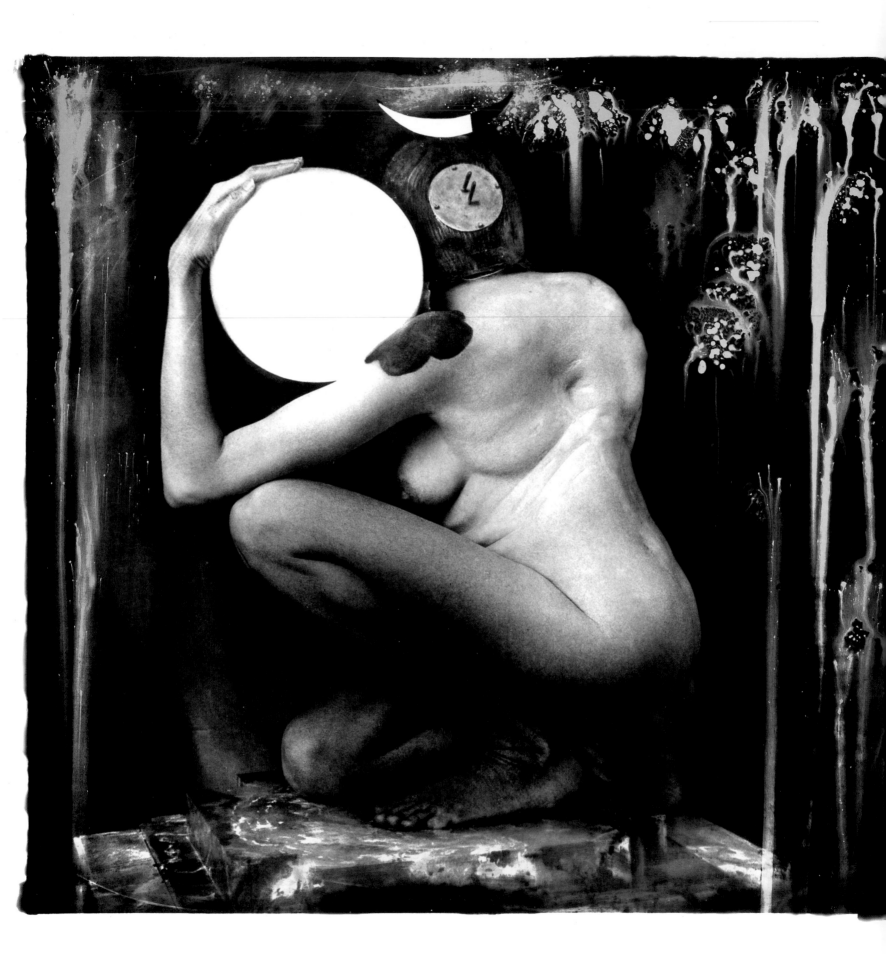

surgically sculptured cadaver. "We're all basically toys," Witkin says of the concept. Why not a female torso? "I get luckier photographing men when they're dead," he explains. "Men remain strong." Other cadavers will be required to realize adaptations of three female portraits by Jacques-Louis David, the heads laterally severed at the brow, which are intended "to make the lips of a dead woman smile." Of the French painter's homage to Countess Daru, Witkin says: "I will make her beautiful again."

Hope lies somewhere between two extremes of reality—the tragic and the grotesque. —Jerzy Grotowski

In the final days of preparation, Witkin had on hand an example of the culmination of his image-making process. The photograph, after Rembrandt, is entitled *John Herring, Person with Aids, Posed as Flora with Lover and Mother*, 1992.

"When I knew John was ill I could basically see a kind of distancing between his physical body and his shadow…as the light was moving toward him, the shadows were longer…his spirit was manifesting itself in a reality that was apparently physical." After Herring posed in a Renaissance-inspired gown made by his mother and his lover, Witkin rushed to make a print and brought it to Herring's hospital room in the final moments of his life. "My belief of beliefs is that we don't perceive with our physical senses. I believe that even if John had been dead a few moments, or even an hour, he could see the picture…see what I'd made through his energy and all the people involved."

What is extraordinary about the massively framed Herring print exhibited on an easel is that it has undergone Witkin's encaustic process. "Burned" onto aluminum, the image is subtly, pointillistically colored by Cynthia Witkin. A layer of wax is applied and buffed with the palm of the hand for up to fifteen hours. After "resting" through three months of temperature changes, the waxing-buffing is repeated, and once again three months after that. Witkin rarely undertakes this arduous process, and then makes only a single encaustic rendering of an image, which becomes a unique work; straight photographic prints of the same image make up his signed and numbered editions.

Witkin's reverential attitude toward dying subjects carries over, somewhat peculiarly, into his studies of human remnants. "When I'm working with a severed head," he says of *Still Life*, Marseilles, 1992, "I'm engaged in very direct spiritual dialogue. This person really had a life. His body is in a coffin somewhere, and part of his brain was taken out for medical research. My job, given the opportunity, is to put flowers into the remainder of his brain, as if it were the well of *my* existence. I'm trying to make a totally humbling image. It's a very crazy and profound experience."

The overwhelming artwork in the studio is a fifteen-by-eighteen-foot background painting to be used in Budapest. It is a brilliant, accurate fusion of Velásquez's landscape with the ocher waters that flow through the lower right corner of the Titian. The

Joel-Peter Witkin, *Art Deco Lamp*, New Mexico, 1992

first attempt—failed—at the equine figure, will lead Witkin into twenty-two hours of nonstop effort in the darkroom. There, he will use special cameras to photograph six sections of a newly photographed horse, enlarging each section to create a royal mount scaled to his background.

In mid July, packing various props, industrial construction foam, special adhesive glues, the background, and all the necessary photographic equipment and supplies, Joel and Cynthia left for Budapest, ten thousand miles distant. And for all the painstaking preparations, he had embarked on a costly, exhausting venture of pure risk—the quest for what he calls "the big shot."

Witkin's absence afforded an opportunity to seek out other participants in his necessarily collaborative photography. One of the most valued is his background painter, Beth Love. "Beth," he says, "endows a painting we both admire with her own outlook and vision. It makes my work richer."

Beth Love shares a World War II Quonset hut in an industrial park with Simon Bolt, an expert restorer of vintage automobiles. Beth has worked with Witkin since 1984. "Initially, he'll give me some idea of what he wants. I work in his studio, and we bounce ideas back and forth. I'm learning from Joel to let go of control in my own painting. And I think more than ever about my own mortality, death."

An intriguing aspect of Witkin's art, inevitably, is his relationship with his models. It can be, by turns, affectionate, distant, and very demanding. Laconic as an ancient Roman governor, he has observed: "I have crucified two brothers." And with these two—Beth's former husband, Carl Love, and his brother, Eric Love—Witkin thrust his vision into extremes of illuminating tragedy and grotesque darkness.

Carl is a slender, blond mental-health worker, chosen for Witkin's epic, life-sized, body-cast sculpture of Christ on the cross, which was also reproduced in photographs. In preparation for what would be nearly eighty hours of posing, Witkin sent his model to an institute for hypnosis. The idea was to master self-induced trances that would help him remain motionless. "I didn't think it worked," Carl says, "but I must have been in a trance. The first session I was up there for about thirty minutes. When I came down I was sick all over the floor. After that, the most I could stay up was fifteen minutes." Carl also fainted several times. Despite the ropes slung for arm supports, and a small platform under the buttocks, he was, essentially, experiencing crucifixion:

"It was physically exhausting, difficult. Joel doesn't go out of his way to make you feel comfortable. He doesn't talk to you or offer philosophical ideas. You're a tool, objectified. But I indentify with Christ because this is a fairly unreal existence. And I thought that this was the kind of image I might look at—and behind—in another lifetime."

In discussing his relationships to models, Witkin has acknowledged his tendency to objectify. "You're not thinking about their personalities or memories. A photograph is successful for me in terms of what the viewer sees in it. Distancing myself from the

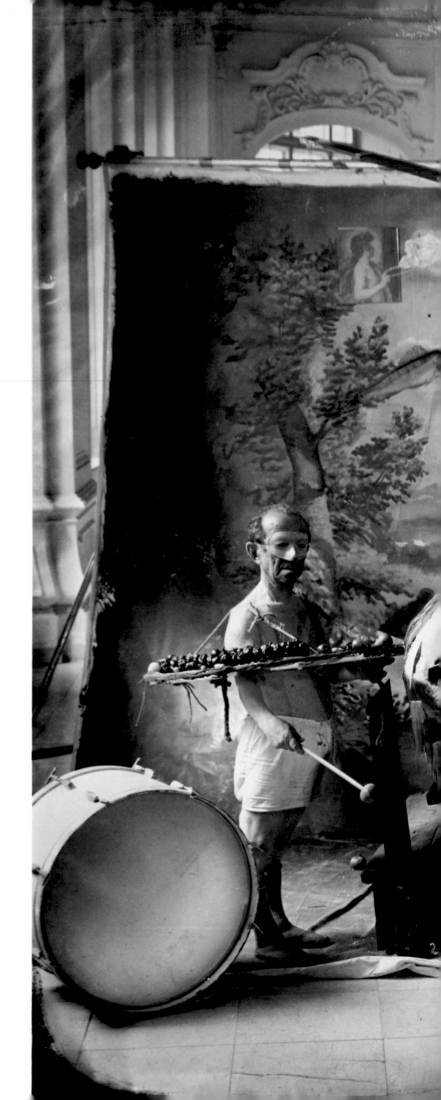

model lets the viewer make different kinds of choices about the subject."

Yet, Witkin also can be utterly engaged with an individual trapped in "the aberrations of love." Carl's brother, Eric, who died of AIDS last year, was the photographer's most frequently used model—the subject of images involving crucifixion, sadomasochism, and bestiality.

"The Grotesque," Witkin reminds us, "derives from grotto, the caverns and subterranean darkness. Saints have loved the darkness because that's where you go to bring out the people who are drowning. When I, as an individual, continue my journey into perception and better realities, I have to engage the person in darkness because I'm in darkness. I have an opportunity to celebrate that person's life. But unless the image of emotional associations represents a moral equivalent of some higher, noble force, it can damage me and others in the process. We all have to make a decision as to what we're basically serving. If your life and work are about despair, there's no resolution, no redemption."

The art of mise-en-scène [has provided] a place of direct contact between artists and spectators, where the attention, thought, and will of the participants are united into a communal plunge into existential problems of human fate, interpersonal connections, and the relationship of man to Cosmos in order to find a seed of hope. —Jerzy Grotowski

In less than a fortnight, Joel and Cynthia returned from Budapest. In his account, abbreviated; "We went there with a filmmaker from Paris. He knew I needed a dwarf, so they had had a casting call and there were forty dwarfs waiting. Hungarians are proud that for some reason they produce a lot of dwarfs. Many of the dwarfs in *The Wizard of Oz* were Hungarian....

"In Budapest, we were given a whole factory to use, which was great, except it had no toilet...only a hole. We worked around the clock.... The film crew and others were loaded into two Mercedes and we went looking in three asylums. In two of them, everyone looked normal, but the third was perfect. The gate was opened by a guard in uniform, and he turned out to be an inmate. In that asylum, we found the right dwarf" (who, it should be added, bears an uncanny resemblance to Velásquez's portrait of *Don Sebastian de Morra*).

"For our location, we had a small copy of a copy of a palace from Versailles, which was important. I was working with a kind of lunatic story about a person in a palace, exerting himself as a signifier of power, iconography filled with the colossal and the portentious. For Titian's *Europa*, the white bull was too expensive, and the gray, spotted bull they sent over looked too much like a horse. So the owner of the slaughterhouse killed a white cow, cut it in half, and we had to drag this carcass of a half-cow into the palace. We used an actor for Philip IV, but I placed a mask on his face that was a photograph of my son, suggesting a kind of blind, adventurous youth. The actress had a pretty good body, but she was quickly fed up with the wax and latex I wanted to use to evoke

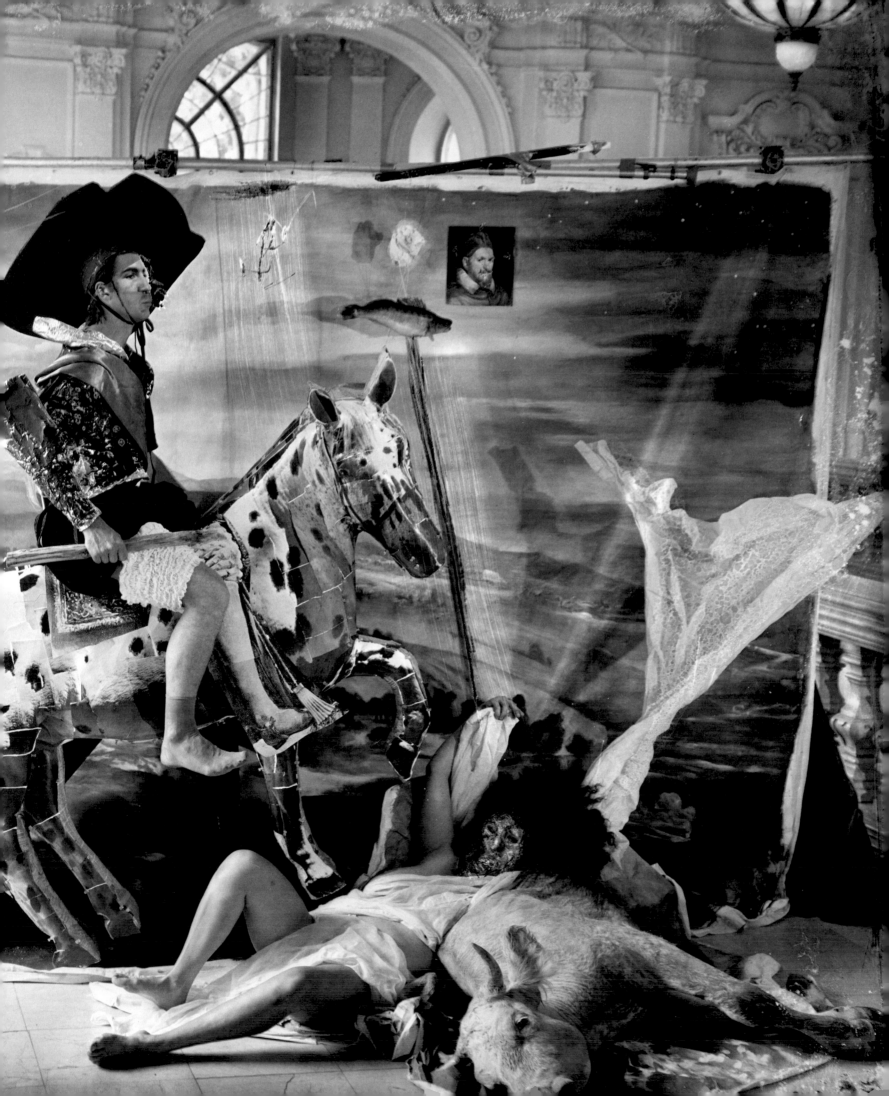

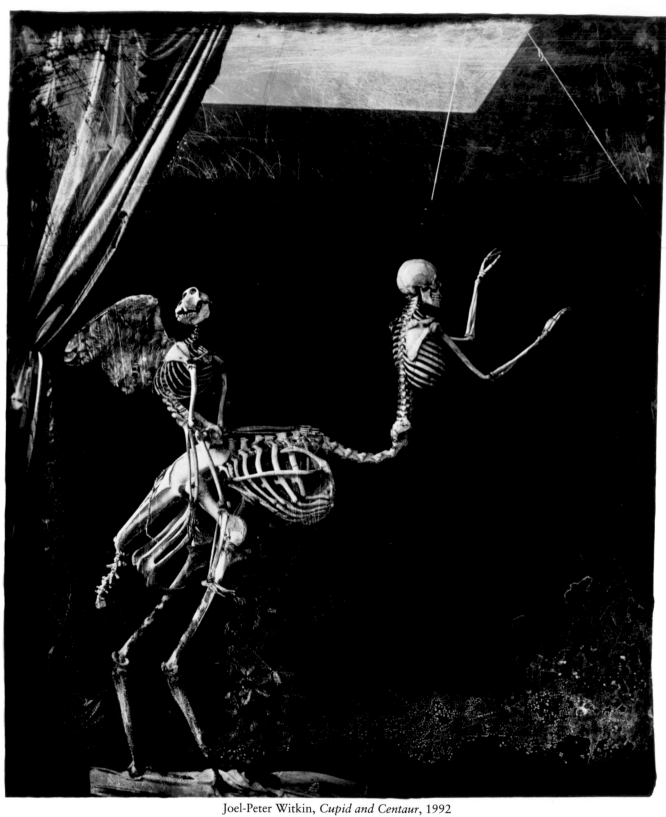

Joel-Peter Witkin, *Cupid and Centaur*, 1992

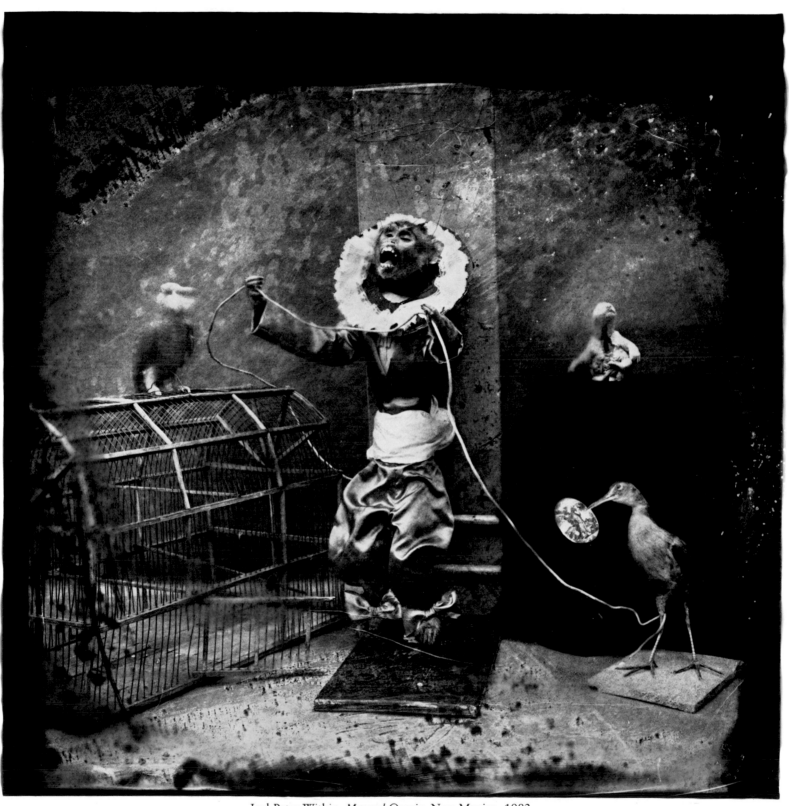

Joel-Peter Witkin, *Manuel Osorio*, New Mexico, 1982

the horrific, raped face from Bacon, which I'll now scratch onto the negative.…The dwarf was covered with feces, so we made him keep his socks rolled up to lessen the smell.

"Cynthia was working with me every minute and we were white with fatigue. Only the hot mineral baths, the healing waters, kept us going. We put all of our knowledge and energy and ambition into making this image occur. I've often felt as if I were working in a trance, but never this hard, never this amount of risk. But it's like St. John's promise that you receive 'grace for grace,' efforts making you ready to receive. By the time it was all put together, I only had about ten minutes to make the shot."

Weeks of intense work ensued before he printed a fulfilled vision of *Raping Europa*, Budapest, Hungary, 1993.

Witkin's hard-won photograph is at once both illumination and satire of a great master's aesthetic stoogery: Velásquez's nearly lifelong devotion to one of the Habsburg's—and Europe's—most vicious, ineffectual rulers. Even a superficial reading reveals the clarity of Witkin's transfigured symbols. The dwarf, bearing a yoke of flowers, represents the populace. Philip IV's mount, slightly reduced in scale, is also diminished from the heroic to the slightly absurd, vaguely in motion but going nowhere. The ideological yields to the deeper spiritual suffering of Witkin's Europa, rape victim of mythology, now expressing Bacon's contemporary irredeemable despair. In place of Titian's robust, almost jovial white bull, Witkin's wretched cow assumes both the posture and pathos of *Guernica*'s agonized dying horse. Velásquez's portrait of Innocent X, the Habsburg-allied pope, hovers at upper right. A flying fish with a parachute embodies, for Witkin, a multitude of meanings, ranging from Christ's healing powers to the idea of peace distorted into missiles, bombs, and environmental rapine. And to the upper left, there is a detail from Velásquez's *The Forge of Vulcan*, that Grand Guignol scene in which Apollo reveals the adultery of Venus with Mars.

Within this elaborate imagery there is a remarkable fluidity of associations: of Velásquez's familiarity with his friend Titian's masterwork; of Titian's patronage in Rome that provided Velásquez with access to the pope; of Bacon's obsession with Velásquez's portrait of Innocent X; and of Philip IV's own historic role in shifting the center of Habsburg power and tyranny to the east…to Hungary, most raped of nations, and to lunatic asylums, shelters of raped souls.

Where is the line between travesty and transfiguration? Or between the dark and light events of the soul? It is a place where rare, fearless artists have gathered for centuries (certainly, long before the invention of photography) and it is within their company and traditions that Witkin belongs. Masters of painting from the Renaissance onward have provided him with a symbolic lexicon; innovators from the Italian Comedy Theater of Cruelty celebrated the robust madness that fires his imagination and labors. Witkin's unique contribution is the use of the camera to adapt and transform this heritage, to inhabit an image such as *Raping Europa* with a stunning, eternal moment and dramatic grace.

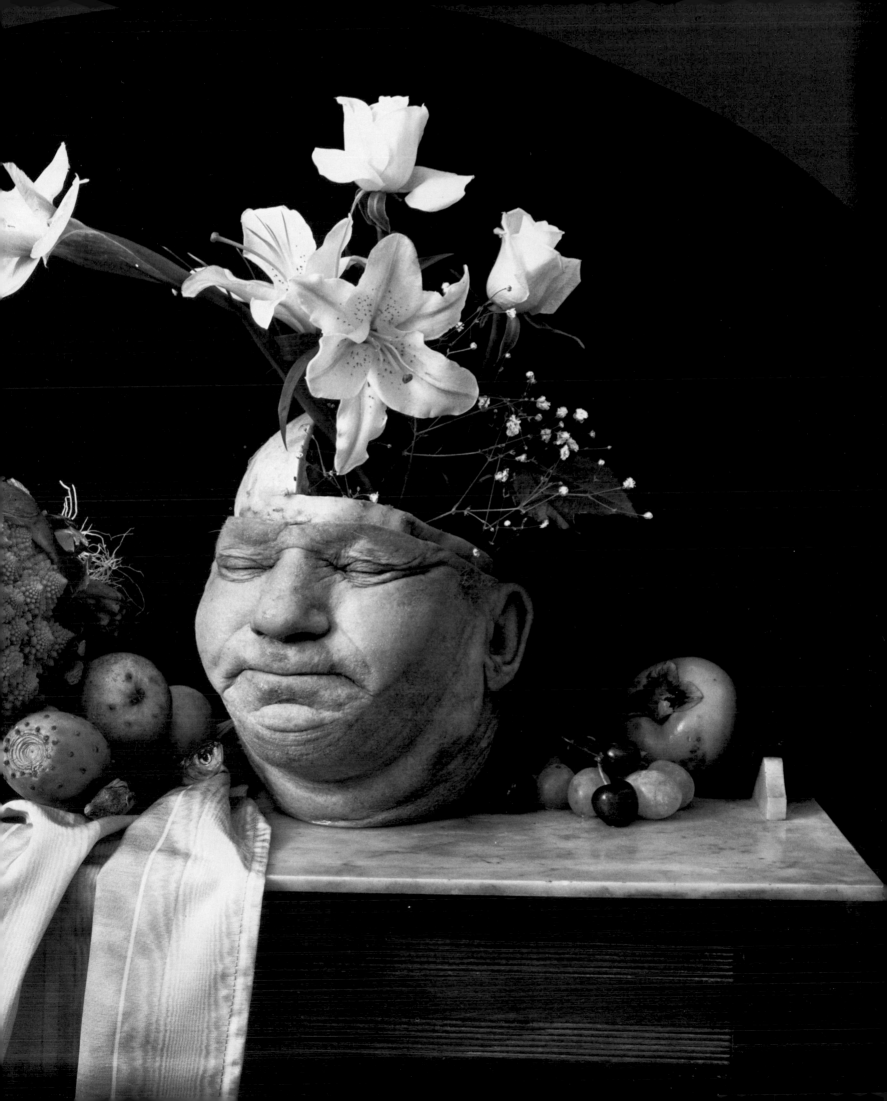

JON GOODMAN

BY ANDREW WILKES

> The varying density of ink creates profound subtleties in the print; in fact, it is not uncommon for photographers to discover previously unseen details from their negatives in photogravures

No other method of printing multiple copies of black-and-white photographs compares in subtlety and richness with photogravure. A continuous-tone process so painstakingly exact and complex as to be arcane, it produces prints unequalled in luminosity and dimensional definition. To Jon Goodman—contemporary photogravure's unquestioned master—what its creators were searching for, "the light-drawn image in ink on paper," is "a mystery of the highest order."

First devised in 1878 by the Czech printer Karl Klic—although the technique also derived from William Henry Fox Talbot's photoglyphic engraving—the process reigned supreme until 1918, after which it precipitously lost ground to quicker, cheaper, mechanical printing methods. By the late forties, despite the fact that such photographic pioneers as Edward Steichen, Alfred Stieglitz, and Paul Strand considered photogravure the apotheosis of the philosophical and aesthetic gesture of making a picture, the method had become largely a glorious memory—accorded the same awe as the illumination of manuscripts perhaps, but a memory nonetheless.

Then, in the early seventies, Jon Goodman appeared. Himself a photographer, the Antioch College student found his imagination caught and held by the mystery and beauty of this all but vanished art. Over the last two decades, he has devoted himself with almost religious fervor to reviving and perfecting the method. He is arguably the only photogravurist working today to realize the dream of making a living solely from it.

THE PROCESS The French term *photogravure* traditionally refers to high-contrast photoetching, which produces a strictly black-and-white print. A photogravure is an ink print, pressed onto paper from a copper plate etched from a film positive. The *heliograph*, or intaglio photoetching, is a tonal process when prepared by means of the Talbot-Klic methods that Jon Goodman employs.

Of the three main varieties of printing processes, the most common for five hundred years was *letterpress*, which is typographic; in letterpress printing, a raised surface is inked and printed, while cutaway areas remain white. *Lithographic* printing, the most popular technique today, depends on the mutual antipathy of oil and water: the image to be printed is ink-receptive, while the blank areas are ink-repellent. Photogravure utilizes the *intaglio* printing process, which obtains tone from recessed areas on the plate that are etched to varying depths, thus holding different quantities of ink. The resulting print produces a continuous range of gray tones, from very light—almost white in the areas not deeply etched—to rich blacks in the deepest areas, creating an extraordinary tonal gamut not available in silver prints. This range seems to become more expansive, its luminosity more variable, depending upon the ambient light levels of viewing—from the front, from behind, from a distance. The varying density of ink creates profound subtleties in the print; in fact, it is not uncommon for photographers to discover previously unseen details from their negatives in photogravures.

THE STUDENT Both as a photographer and gravurist, Jon Goodman is a self-admitted Romantic in the late-nineteenth-century tradition of William Morris. He has always resolutely rejected the current and fashionable in favor of, as he puts it, "the philosophy of craft—of making something well, of incorporating an aesthetic and vision which deepens the power of each picture." Early on, the young photographer demonstrated his diametric opposition to prevailing counterculture aesthetics by selecting the 4-by-5 view camera over the more popular 35-millimeter model. Struck by the pristine clarity of its large-format negative, he set out to master perspective, rise and fall, shift, tilt, and the swing of the view camera, using back-country settings as his subjects. But Jon Goodman's greatest, most life-altering discovery was still to come.

While in high school, Goodman had been enormously impressed by Paul Strand's "Mexican Portfolio"—considered with *Camera Work* and the Stieglitz gravures to be the most important work in photogravure ever done. Then, in 1971, at New York's Metropolitan Museum of Art, he was able to view closely Strand's original prints. The experience would transform him: the pursuer of perfection had glimpsed his grail. Subsequently, Goodman was awarded, through Antioch, the prestigious Thomas J. Watson Foundation Fellowship, which funded a year of independent postgraduate study and travel abroad. His course was clear—he would spend the year learning photogravure.

Realizing that ambition, however, was far more tortuous than

Jon Goodman, *Cabbage*, 1990

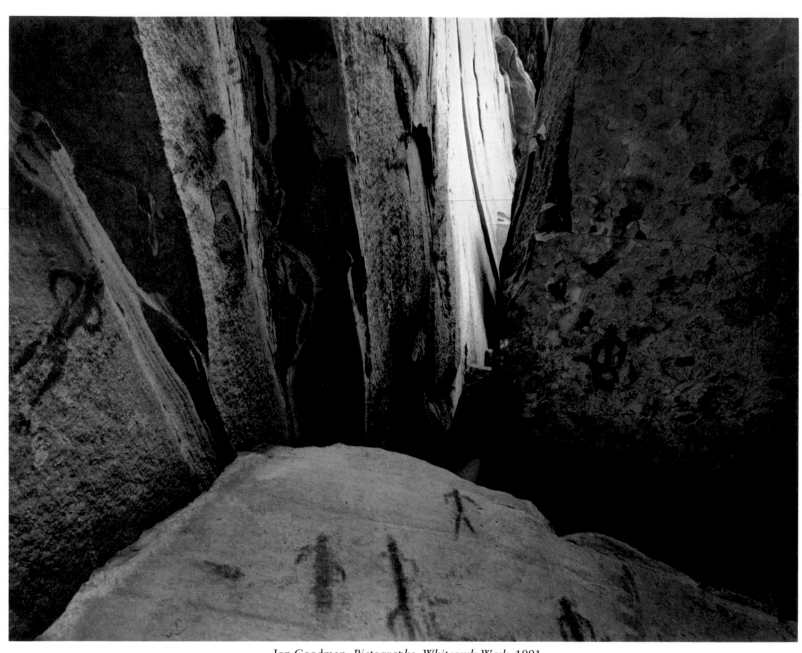

Jon Goodman, *Pictographs, Whitcomb Wash*, 1991

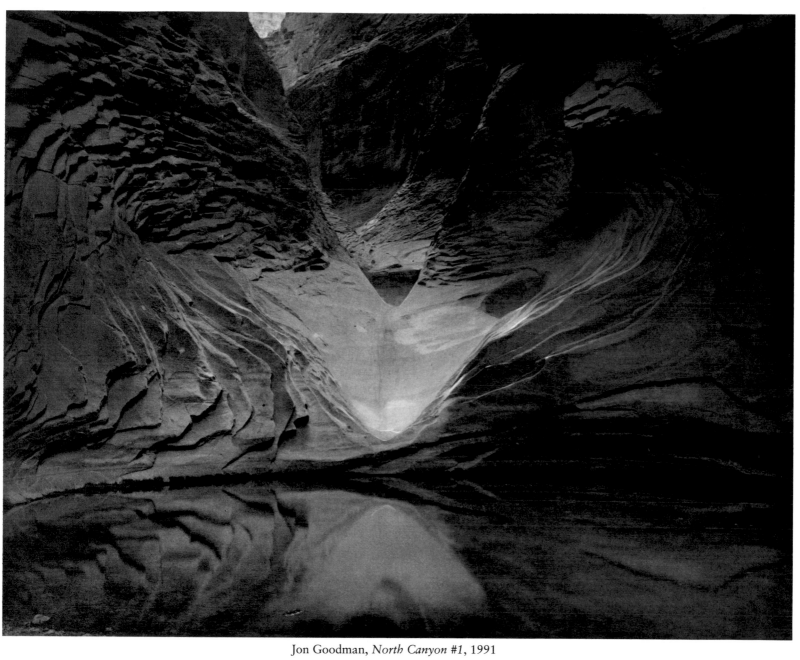

Jon Goodman, *North Canyon #1*, 1991

Goodman could ever have imagined; he wrote countless letters attempting to locate practicing photogravurists, but was invariably disappointed. "It was something that was literally dead," he recalls, "and such a mystery that simply trying to find out where I could go to learn, who knew about it, was almost impossible." But Goodman was a man with a mission who would not be denied.

Following his graduation in 1976, he scoured Europe for a place to study, buoyed by his bible, Herbert Dennison's *A Treatise On Photogravure* (first published in 1865 and reprinted in 1974 by Visual Studies Workshop). Eventually, he happened upon the Centre Genevoise de Gravure Contemporaine in Geneva, Switzerland, a printmaking establishment that made its presses, etching room, rudimentary basement darkroom, and vacuum table available to him. "The way I learned to do photogravure," he remembers, "was to make every mistake possible and find the solution." Still, after three frustrating months, Goodman's vision quest began to bear fruit: he had made his first successful gravure plate.

At the end of 1977, Goodman met with the Atelier de Taille-Douce in Saint Prex, Switzerland. Although the workshop's raison d'être was making very fine *à la poupée* prints—multicolor engravings made in one pass of a press—the artisans expressed an interest in collaborating with him on photogravure. They were engravers and painters, while he was a photographer, but working with them enhanced Goodman's perspective and versatility in printing. The aspiring photogravurist was learning his craft.

THE CRAFTSMAN Intent on making photogravures, Goodman returned to New York in 1978, and, after talking with galleries, artists, and publishers, contacted the Aperture Foundation. This felicitous meeting resulted in an invitation by the foundation's director, Michael Hoffman, to test the process on a series of Paul Strand photographs. Goodman felt uneasy about the project since up until then he had worked only from his own negatives; but passion prevailed, and his work commenced.

Goodman's first Strand gravures, *Fisherman, Gaspe* and *Iris, Maine*, were made in collaboration with Strand's master printer, Richard Benson, in Newport, Rhode Island. Strand had died in 1976, but Goodman says, "Benson knew each negative by heart." The test, which was to take two weeks, stretched into three months, at the end of which he had the first plate.

Goodman—with just enough money to feed his dog, if not always himself—was able to remain in Newport largely due to the generosity of Benson and his family. Then Hoffman suggested the gravurist relocate to Millerton, New York—where Aperture's Strand Archive was situated—and talked of establishing the Photogravure Workshop, to be started up under the aegis of and with the financial aid of Aperture.

At Millerton, Goodman began resurrecting "The Early Years: Edward Steichen," the photographer's last great project, which Steichen had asked Hoffman to undertake in 1968. The first plate had been well crafted and successful, but subsequent ones failed; ten years later, the portfolio remained unfinished. Goodman traveled to Germany and Switzerland on stipend from Aperture to iron out

68 Jon Goodman, *North Fork, Flathead River*, 1990

details, then, back in America, arranged to make the plates in Benson's studio. Creating the twelve plates took one full year. The portfolio was printed at Goodman's alma mater, the Atelier de Taille-Douce, where the gravurist stayed for another year while the work was in process. The production of the portfolio was an extraordinary feat: twelve plates, six hundred prints per plate, totaling 7,200 final prints.

Once the project was completed in 1981, Goodman settled in Millerton, living in the home of Hazel Strand, Paul Strand's widow. Committed to ensuring that the photogravure process so cherished by her late husband would not be lost, Hazel joined Aperture as a Goodman patron, helping him purchase equipment and supplies. It was here that he finally custom-designed and supervised the construction of a press by a master machinist in Millerton from old Swiss plans. The Photogravure Workshop had come to be.

THE MASTER During the Millerton period (1978–1984), Goodman produced in collaboration with Aperture the portfolios "The Formative Years: Paul Strand 1914–1917," "The Golden Age of British Photography," and the aforementioned "The Early Years: Edward Steichen." He also produced single gravure prints, including: *The Spinner*, by W. Eugene Smith; *Migrant Mother*, by Dorothea Lange; and *Wire Wheel*, by Paul Strand. All the while, he went on refining his technique, imparting a look and level of quality unique to his gravures, while maintaining fidelity to the photographer's vision far beyond what anyone thought possible.

In the fall of 1984, Goodman moved the Photogravure Workshop to its permanent home in Hadley, Massachusetts, a thriving arts center affording him both solitude and community. He continues working with Aperture, having recently produced the Paul Strand *White Fence* gravure, made from the original catalog negative and unpublished to date, and developing the large-format Hill and Adamson portfolio. At the same time, he pursues such independent assignments as printing photographs by Robert Mapplethorpe, Joel-Peter Witkin, Brassaï, Walker Evans, William Clift, and André Kertész, among others. "Somehow or other, people find me," he notes. He also perseveres with his own photography, examples of which appear here.

When asked what has motivated him to struggle so long for perfection and sacrifice so much to concentrate on photogravure, Goodman replies, "The pursuit of a mystery: a beauty dreamed of, the indescribable effect on a man's soul of the marriage of ink and paper, born of a technical discipline, but whose magic lies in its very presence and effect on the viewer. Or," he adds wryly, "maybe it's as simple as stubbornness."

Jon Goodman, *Side Aisle, Vezelay, St. Madeleine*, 1981 71

Last spring, Jon Goodman demonstrated the photogravure technique for Aperture *using his 1991 work,* North Canyon #2.

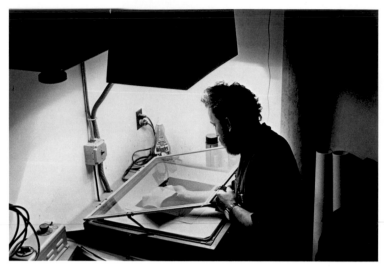

1) The Talbot-Klic photogravure process is a photo-mechanical means of making a photographic image in ink on paper from an etched copper plate. A continuous tone (not a halftone) film positive is made to size from the original negative. The film positive and gelatin-coated paper are placed under ultraviolet light and exposed. This paper is commonly known as carbon tissue and is made light-sensitive by soaking in a cold solution of potassium bichromate. In its original, dry state, the gelatin-coated paper is not light-sensitive.

2) The carbon tissue is then adhered to a polished and de-greased copper plate that has been submerged in water. The carbon tissue/copper plate is developed in hot water, which softens and melts the unexposed gelatin. The light's action through the positive hardens the gelatin in proportion to the amount of the exposure received. Dark areas receive a thinner layer of gelatin; light areas a thicker layer. When the carbon tissue is fully developed, the image is visible on the plate. Varying thicknesses of gelatin result in tonal differentiation, darkness corresponding to the relative thinness of gelatin. At the end of the development, the plate is soaked in alcohol. The alcohol absorbs all the water in the gelatin, and the carbon tissue on the copper plate, now called a "resist," is dried. The plate is now extremely sensitive and must be carefully protected from outside interference. It must stay in a set environment and not be exposed to any significant temperature or humidity differentiation.

3) The portions of the plate that are not to be etched (principally the borders) are then stopped out using an asphaltum varnish dissolved in turpentine or mineral spirits, which provides an acid-resistant coating. The aquatint (dust grain) is then applied by means of a dusting box. (Alternatively, it may be applied to the de-greased plate before the carbon tissue.) The fan in the box creates a cloud of colophane resin dust and the plate is introduced into the box. The dust is then allowed to settle onto the surface of the plate. The aquatint preserves approximately 50 percent of the original plate area onto which the photograph is etched, thus creating the pits that carry the ink and that hold the image. When the plate is sufficiently covered by the resin dust it is removed and gently heated until the dust grains melt and adhere to the plate. The plate is then put aside for a period of hours for cooling.

4) The etching of the plate is accomplished in a copper mordant, iron perchloride (commonly known as ferric chloride, or iron salt). Etching normally occurs in a series of solutions of differing specific gravities measured in degrees of the Beaume scale, from forty-four to thirty-eight degrees.

5) The iron perchloride is poured over the plate and constantly agitated. Once the etching has begun, it cannot be stopped. This takes anywhere from fifteen minutes to an hour. The thin areas of the resist (the dark tones of the image) begin to etch first in the dense solutions of mordant. Gradually the etching progresses to the thicker areas of the gelatin (lighter tones of the image) aided and controlled by changing to lower densities of the mordant, which penetrate the resist more rapidly until the entire image is seen to be etched.

6) The gelatin surface, or resist, has served its purpose. The plate is removed from the mordant, rinsed to remove the resist and asphaltum varnish, thoroughly cleaned with water and muriatic acid, and then gently wiped with a piece of cotton. If the plate is a success, and is to be used for an edition, the copper plate is faced with either steel or chrome to create a harder surface. This extends the life of the plate and protects the surface from the abrasive action that occurs on the press.

9) A dampened sheet of fine-quality printing paper is placed on the plate and printing felts placed upon the paper. The whole is passed through the rollers of the press. There is a tremendous amount of pressure between the two rollers, which squeeze or push the paper fibers down into the plate. The felts are removed and the print lifted from the plate. When the paper comes off the press, it is still damp and needs to be dried. To avoid shrinking and waves in the paper, the prints dry overnight, under pressure, flattened between blotters.

7) The plate is printed using an intaglio printing press. A stiff ink is applied to the warmed plate in such a way that it penetrates into the intaglio recesses of the plate.

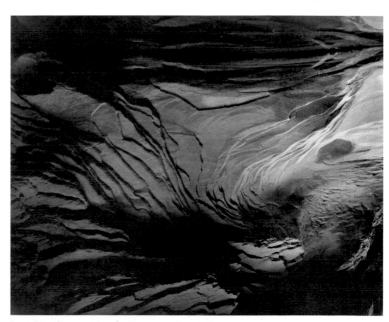

Jon Goodman, *North Canyon #2*, 1991

8) The surface of the plate is wiped with a muslin rag, then with the palm of the hand until the ink is removed from the surface but remains in the etched recesses of the plate. The borders are cleaned and the plate is placed on the bed of the press.

PEOPLE AND IDEAS

INTO THE ABYSS

By Danny Lyon

We asked Danny Lyon to review Don McCullin's autobiography, and in the process, a conversation between the two photographers transpired.

Unreasonable Behavior: An Autobiography, by Don McCullin. Alfred A. Knopf, New York, 1992. $24.00.

One of the things that sets much of photography off from the other arts is that it is not created in the quiet isolation of a room or a studio. Consider war photography, which is done in the midst of extreme violence. One of Don McCullin's pictures, made during a Christian Falangist pogrom in

Don McCullin, Turkish woman discovers the bodies of her new husband and brother killed by the Greeks during the civil war, Cyprus, 1964

Beirut, shows a man playing the mandolin while his buddies threaten to shoot McCullin if he makes the picture. What could be more insane? What Don McCullin did was more insane. He ran around in the midst of battles with a Nikon Reflex. In an age dominated by television's reprocessed experiences, Don McCullin's autobiography, *Unreasonable Behavior*, is an absolutely riveting firsthand account of photography and war.

McCullin grows up in Finsbury Park, a poor, working-class district in London, with his brother, Michael, and a father who is often too ill to support them. Don's most frightening experiences are during wartime evacuations from London during the Blitz. His first break in photography comes when a policeman is murdered in his neighborhood. Don makes pictures of the local tough guys, who are in fact his friends. It leads to a publication fee several times his weekly wages.

Later on, at work for the *Observer*, McCullin makes a trip to Berlin as the Wall is being put up, and then goes on to his first war, in Cyprus. This is where he makes his first timeless photographs of war.

Two dead men lie inside a house, recently shot, one facedown in a great pool of his own blood, the other lying just beneath the photographer, on his back, eyes wide open. McCullin: "The room was warm with the smell of blood. I was really scared and tried not to look into their faces." He also had to try hard not to step in the blood. "I always thought corpses would threaten me. I always thought they'd try to sit up and touch me and drag me down." It is his first encounter, as a photographer, with death. In the Congo, where he goes next, he is also afraid of falling into the corpses he is photographing. But what is most disturbing to him there are the chil-

dren starving in a school—eight hundred of them. McCullin: "They came up and clung to my legs. I tried not to look down. I didn't want to look at them." He cannot bear to look at what he wants us to look at. His Nikon is his sword and shield.

Despite his personal horror at what he sees, McCullin repeatedly submits himself to the most outrageous personal dangers. "I don't believe you can see what's beyond the edge unless you put your head over it; I've many times been right up to the precipice, not even a foot or an inch away.

Don McCullin, Young albino boy suffering from malnutrition, Biafra, 1969

That's the only place to be if you're going to see and show what suffering really means"; and then, "How could I live unscarred after all that?"

Trying to photograph in Uganda, McCullin is captured by Idi Amin. While he waits in his cell with other journalists and prisoners they listen to the screams of people being tortured. And then to the sound of prisoners being executed by having their brains smashed with sledge hammers. Again, McCullin survives. In the Congo, in India, in Vietnam, in the rain forests of South America—with children and a wife back home on the farm—he

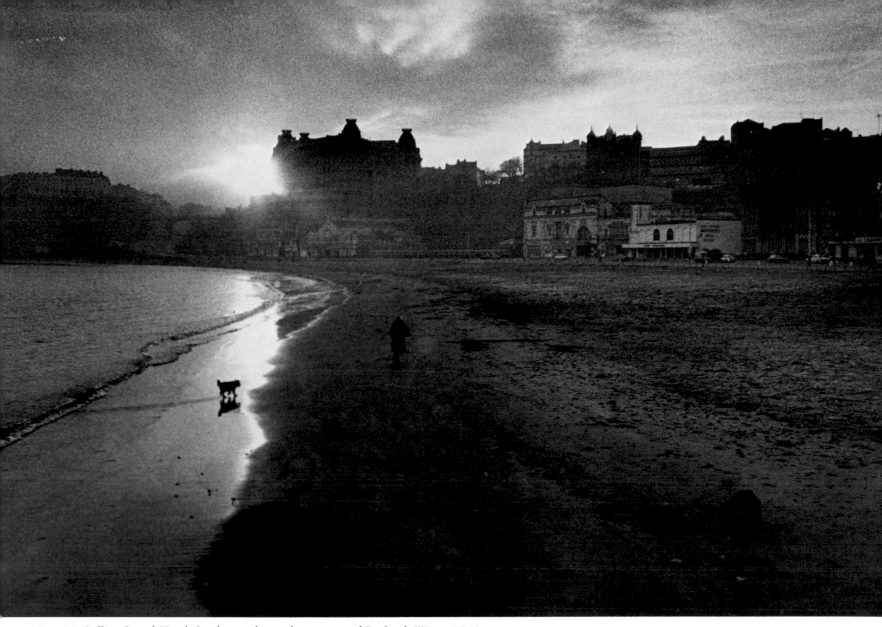

Don McCullin, Grand Hotel, Scarborough, northeast coast of England, Winter 1965

makes a living by photographing the most violent, murderous, or destitute people he can find.

In the 1968 Tet offensive in Vietnam, which, before it ended, killed thirty-seven thousand people, the city of Hue fell to five thousand Vietcong and North Vietnamese. McCullin goes along with the Marines as they try to recapture the citadel. He makes a photograph directly behind a marine who is hurling a grenade, which sails across the frame like a baseball. Soon, the man is shot in the hand. The marine who replaces him is killed immediately. A grenade goes off near McCullin, killing another man and hitting McCullin with flying dirt, rocks, and debris. With men dying around him, he focuses, composes his pictures, is conscious of everything in the frame. Taking light readings and loading his Nikon are even more dangerous for

him than making photographs because he must briefly stop moving, thus making himself a target.

Although the North Vietnamese are trying to kill him, he never considers them to be his enemies. "One day I took a picture...of a dead Vietnamese with all his scattered possessions arranged around him in a sort of collage. It was composed, contrived even, but it seemed to say something about the human cost of this war." In fact the picture is a masterpiece, a dead man over whom we shall weep forever, as with the photography of war dead done by Gardner and O'Sullivan in the American Civil War. Other photographers go to war. Almost none of them is capable of making a photograph that is ironic, damning, mysterious, and beautiful.

The book goes on to tell of McCullin's adventures and damages suffered. In Cam-

bodia, as he flees the murderous Khmer Rouge, his Nikon is hit and left with the perfect impression of a round from an AK-47. Soon after, McCullin is hit by a mortar and seriously wounded. In El Salvador, he falls off a roof and breaks his arm in five places, an injury that takes two years to heal.

In the 1980s, as he watches magazines and newspapers replace journalism with what he calls "style," he publicly complains in an interview about his employer, the *London Sunday Times Magazine*. After eighteen years of working for the *Times* he is fired. Hit with a series of personal tragedies, he ends up alone, haunted by ghosts. He is particularly troubled by a child he photographed in Biafra, a starving outcast who followed him around while he made pictures. "With this book perhaps they will be set free," he writes of his

Don McCullin, Somerset, en route home from London, 1989

ghosts. Perhaps Don McCullin will also be set free.

Danny Lyon: Noam Chomsky argues that the media in America is in effect controlled by an oligarchy, and consequently, mass public opinion (which is crucial in a democracy) is constantly manipulated in a very sinister way.

Don McCullin: He's right. The media has been totally manipulated for years. The Iraq and Falklands wars are classic examples. I was excluded by the British government from going to those places. They wanted to take a load of inexperienced people down there, so that they could control them. The guys sat on a boat for eight thousand miles, through the most violent southern seas, only to be told when they got there that they couldn't go ashore because they didn't have the right boots. Then, right afterward, came Grenada. The Americans thought, "If the British can control their media, we can do it too. Because the Americans blamed the media, primarily, for their loss in the Vietnam War, even though they were naive to do so.

Then there was the Iraq War and again, you had this thing called "the pool system." There were one thousand correspondents completely corralled in there with no hope of seeing the real truth, and being fed information the way you would feed a baby from a jar.

DL: When you went to war, wasn't it really very hard to leave home? Isn't going back and forth a tormenting experience?

DM: In the beginning I was excited to leave. But in the end I used to have an almost religious experience at London airport. I used to look around at people, and see them as going through the motions of talking, and I couldn't hear their voices because I was so deep within my own psyche. I was beginning to say, "Am I looking at this for the last time? Will I be killed on this next assignment? Will I never see this again?" I used to be in a sort of emotional trauma at airports, but would never show it to anybody. So yes, it was bad to leave every time. Now I feel bad for another reason. Going away from sanctuary, really, because I've got my negatives here and my darkroom, and when I part from them, it's like parting from another form of family. They are familiar to me. This house is familiar to me, this garden. I feel very close to life at the moment.

DL: What kind of pictures are you making now?

DM: I do landscapes and still-life photographs, and I want to come do them in America.

DL: Do you ever think how your life was changed—this all happened to me because of a camera?

DM: This all happened because two boys I went to school with were involved in a gang war where a policeman was killed. And the man who killed him was executed by the state. So you can say that I started my life on a note of death—a murder and an execution. The camera was a key to open up my life. It was like opening a huge window to the world. It gave me education, it gave me hope, it gave me travel, and at the end, after giving me all those things, it started taking things away from me. It took my mind away from me, it took things back from me. You don't own those things in the beginning. You don't *own* yourself in the beginning, you're just dumped on this earth and you have to stand up and try to walk and try to get through it.

DL: Almost ten years ago in Beirut you told Yan Morvan you were giving up war photography. Did you? Or did it just last until Iraq?

DM: It lasted until Iraq. You know, I'm like a drunk who passes a liquor store—I go past it and my mouth starts trembling. That's what happens when I see war on television. I can't help it. I was a war junkie really—it's out of my control. When I see gunfire on television, I'm drawn to it.

DL: Why is it that so few of the men and women who actually work in the media speak up?

DM: They're afraid of losing their jobs. You know what worries me, really? In the 1930s, in Germany and Europe, people like you and I would have been the first to be shipped off to concentration camps. Because we spoke our minds. There are no concentration camps now. Yet there aren't enough people speaking their minds.

DL: Because the people who run things don't need them. They're so successful in the way they do it now. They could buy me off with a couple of vintage prints, they could have you do an ad, or give you a ribbon, and go on with the Falklands War. [McCullin was recently made a Civil Commander of the British Empire by Queen Elizabeth.] Regis Debrey says that in the capitalist countries they reward artists because we are ineffectual.

DM: That's really disturbing. Thanks very much—now I'll have a really bad evening tonight [laughs]. You and I have really been a pain in the ass to our countries. You photographed the Texas prison and showed how inhumane it was. Let's hope someone else comes along and has the same inspiration that you and I had.

DL: They've been inspired to quadruple the size of the prison system. And that doesn't affect any of today's political movements or the photography grants one bit.

DM: You know something. They've just

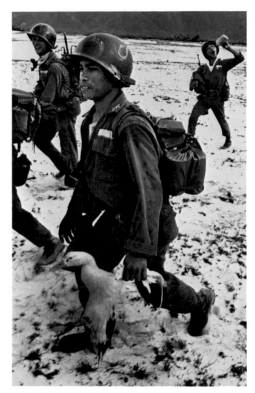

Don McCullin, South Vietnamese soldiers on a search and destroy sortie. After destroying the village, soldier takes a duck to eat later. Near Danang, Vietnam, 1968

given Salgado about a million dollars. Kodak has.

DL: It's a big buy-out. They hang the pictures in buses in New York. And what does that mean? Should bus riders feel comforted that since Kodak is behind the workers all must be right with the world? My thirteen-year-old has a sign on his wall that reads "Corporate Rock Sucks." Well now there's something called "Corporate Photography." It's corporations calling the shots in the world of photography. If Kodak is behind you they'll make six copies of your exhibit, with prints big enough to sleep on and put full-page ads in the *New York Times*. So the corporations, who already own the media, have now bought up photography.

DM: The smart person will figure it out for himself in the end. Photography's a case of keeping all the pores of the skin open, as well as the eyes. A lot of photographers today think that by putting on the uniform, the fishing vest, and all the Nikons, that that makes them a photographer. But it doesn't. It's not just seeing. It's feeling.

Don McCullin, East Beirut, Lebanon, 1975

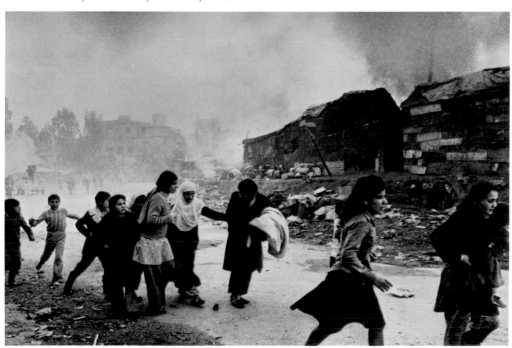

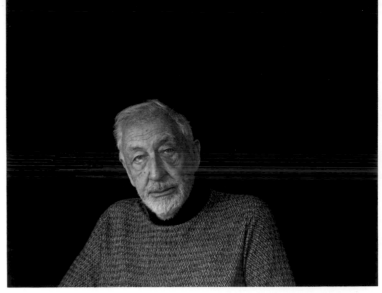

Arthur M. Bullowa in 1986. Photograph by Mariana Cook.

REMEMBERING ARTHUR BULLOWA 1909-1993

By Peter C. Jones

Arthur Bullowa matured in an era in which it was widely accepted that the early support of visionary work was crucial to cultural evolution. As president of Aperture from 1967 to 1980, he freely imparted his energy, wisdom, and advice. Through his guidance, Aperture developed a carefully focused and businesslike publishing program. He helped to ensure that photography would come to be seen as a primary art form of the twentieth century.

Born in New York City in 1909, Bullowa was a Harvard graduate, a Rhodes Scholar, and, for fifty years, an independent Manhattan lawyer who subscribed to the principle "never be trapped." An individual of rare insight, intelligence, and cultivation, he had the ability to distill any situation, no matter how complicated, down to the simplest possible terms and then deal with it directly.

When Michael Hoffman first approached Arthur Bullowa in 1965 to assist him in rekindling *Aperture*, the periodical was just emerging from oblivion. There was no money, no staff, no office, and no inventory. Bullowa had been a retaining subscriber for many years and instantly grasped Hoffman's vision. However, he also understood the pitfalls of publishing fine photography. "Do you have enough money to live for a year?" he asked.

It really took three or four years to get Aperture going—with Arthur Bullowa's daily involvement. Hoffman ran the magazine and the developing book-publishing program out of the third floor of a Ninety-first Street walk-up. They went over everything from grant proposals and correspondence to distribution and publication rights. For the first time Aperture had real contracts. When Hoffman and his wife bought a house near Millbrook, New York, he and Bullowa frequently spent the weekend shaping Aperture's business, management, and publishing strategies.

The Diane Arbus monograph was pivotal. Six publishers had turned it down, because they believed it was too radical to attract an audience and because Arbus had no model releases. Bullowa wanted to go forward, counseling that publishing important work with a limited market was everything Aperture should be about. As for the releases, his advice was, "If someone complains, we'll deal with it."

There was only one complaint, from the parents of twins. Arthur settled it by removing the photograph from subsequent editions and arranging for the Museum of Modern Art to take the picture off the wall. To date Aperture has sold over 250,000 copies in six languages, and Arbus is viewed as one of the central figures in the history of modern art.

Arthur's interest in art began as vice president of the Junior Council at the Museum of Modern Art, for whom he ran the Art Lending Service on Saturdays. He moved from the Junior Council to the Photography Committee, where he also became vice president. With the attentive ears of curator John Szarkowski and publisher Michael Hoffman, Bullowa wielded considerable power in what was then the only game in town.

Most of Arthur's friends and clients were connected with the arts, including photographer Josef Breitenbach and painters Fairfield Porter and Alice Neel. Arthur first learned of Alice Neel from the writer Max White, who said, "I'd like to introduce you to my friend Alice Neel, but we're not on speaking terms." Ultimately, Arthur and Alice became close friends, and he hosted numerous champagne birthday parties packed with Alice's friends and family.

Arthur Bullowa was a voracious collector, assembling fourteen paintings each by Alice Neel and Fairfield Porter and one of the largest collections of pre-Columbian art, including Mayan ceramics, Olmec jades, and Peruvian textiles. The Metropolitan Museum published catalogs for two separate exhibitions drawn from Bullowa's collection, organized by Julie Jones: *Andean Four-*

Arthur Bullowa was by nature not an enthusiast but a connoisseur. His standards were high, but not compulsively broad; he was more interested in quality than in variety, and not at all, I think, in novelty.

Although he was an altogether urban person, his favorite contemporary photographer was Robert Adams—not because Adams's photographs showed the countryside, but because they embodied qualities that Bullowa prized: precision of expression, economy of means, independence, responsibility, and comity—due regard for the rights of civilized tradition.

As he grew older these qualities seemed less and less esteemed. Bullowa did not complain about this, and because he was a gentleman he did his best to protect his friends from his own less-than-sanguine view of the late twentieth century.

JOHN SZARKOWSKI, former Director, Department of Photography, Museum of Modern Art

Cornered Hats and *Houses for the Hereafter*, for an exhibition of funerary temples from Guerrero, Mexico.

Bullowa lived in a handsomely appointed penthouse on Madison Avenue and Seventy-fifth Street. He loved to tour visitors through his collections and then lead them out to his wraparound terrace, over to the Madison Avenue side, saying, "If you come over here, we can look down on the Whitney Museum."

The garden was a centering force. Arthur rose early to water it and harvested enough crab apples for Elizabeth Riley to make crab-apple jelly, which he would present to astonished hosts at dinner parties. Landscape architect Charlotte Frieze and I struck a wonderful deal: we would take care of the garden and he would give us legal advice. Three years after she introduced the first flowers, the garden was in bloom eleven months of the year.

While today's collectors buy and sell, Arthur bought and gave. He donated more than eighty pre-Columbian objects to the Metropolitan Museum, about forty textiles to New York's Textile Museum, many photographs to the Museum of Modern Art, and his best two Neels, *Loneliness* and *Portrait of Hartley Neel*, to the National Gallery of Art in Washington, D.C., to complete their Alice Neel room. Arthur left his pre-Columbian collection to the Metropolitan along with his Fairfield Porter paintings.

He was ultimately trapped by failing health. During the last years of his life, his longtime friend Hilda Bijur saw to his medical needs. No one could have received more compassionate care. Arthur Bullowa died in his sleep on June 8, 1993.

CREDITS Unless otherwise noted, all photographs are courtesy of, and copyright by, the artists.

Cover photograph by Joel-Peter Witkin; p. 8 photograph copyright the estate of Robert Mapplethorpe, courtesy Robert Miller Gallery; pp. 14–15 Polaroid prints by Lorna Simpson, 73½ x 25", courtesy Josh Baer Gallery, New York; p. 16 photograph by Andrew Wilkes; p. 18 Lorna Simpson, photolinen, steel, and glass, photograph 42 x 28¼", courtesy Josh Baer Gallery, New York; p. 19 top: four Polaroid prints by Lorna Simpson, 40 x 103", courtesy The Museum of Contemporary Art, Chicago; p. 21 Lorna Simpson, 18 color Polaroid prints, 21 plastic plaques, 91" x 31", courtesy collection of the Museum of Contemporary Art, San Diego; p. 22 Lorna Simpson, three silver prints and wooden screen, 2 x 62 x 66", courtesy The New School for Social Research, New York; p. 23 Lorna Simpson, three silver prints and wooden screen, 2 x 62 x 66", courtesy The New School for Social Research, New York; p. 24 top: photograph by Sevruguin, courtesy Freer Gallery of Art/Arthur M. Sackler Gallery Archives, Smithsonian Institute, Washington, D. C.; p. 24 bottom: Archibald Roosevelt, courtesy the Library of Congress, Washington, D. C.; p. 25 top row: contact sheet from the collection of Hajek Muhamed Hajek Shirwani; p. 25 bottom row: contact sheet from the collection of Zirar Sulaiman Sulaiman Beg and Zoya Ismailova, Iraqi Kurdistan; p. 25 bottom: photograph by Susan Meiselas, courtesy Magnum Photos, New York; p. 26 top: photograph by Robert Montagne, courtesy the Bibliothèque Nationale, Paris; p. 26 bottom left: postcard from the collection of Ibrahim Ahmed; p. 26 bottom center and bottom right: Percival M. Sykes, courtesy the Royal Geographic Society, London; p. 28 photograph by Laura Hubber; p. 27, p. 29, and p. 30 center: photographs by Susan Meiselas, courtesy Magnum Photos, New York; p. 30 bottom left: anonymous photograph from the collection of Gew Mukriani, Iraqi Kurdistan; p. 30 bottom right: photograph by Rosy Rouleau, courtesy Sygma, New York; p. 31 top right: Henry Field, courtesy the Field Museum of Natural History, Department of Anthropology, Chicago; p. 31 bottom: photograph by Susan Meiselas, courtesy Magnum Photos, New York; p. 33 photograph by Susan Meiselas, courtesy Magnum Photos, New York; pp. 34–37 photographs by Cindy Sherman, courtesy Metro Pictures, New York; pp. 38–39 video stills courtesy Michael Auder, 1989; pp. 40–43 photographs by Cindy Sherman, courtesy Metro Pictures, New York; pp. 44–53 photographs by Adam Fuss, courtesy the artist and Robert Miller Gallery, New York; p. 54 photograph by Robert Reck; pp. 55–63 photographs by Joel-Peter Witkin, courtesy Pace/MacGill Gallery, New York; pp. 72–73 photographs by Andrew Wilkes; p. 78 photograph by Mariana Cook, 1986.

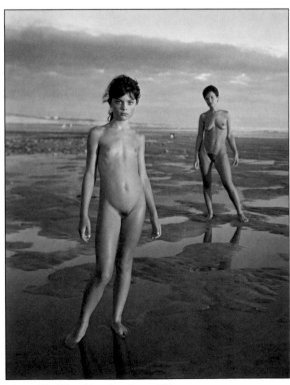